IRISES

VINCENT VAN GOGH IN THE GARDEN

IRISES

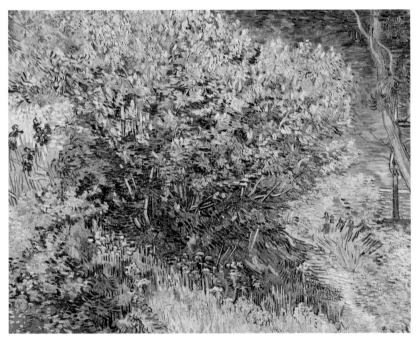

4. Vincent van Gogh, *Lilacs*, May 1889. Oil on canvas, 73 × 92 cm (28¾ × 36¼ in.). St. Petersburg, State Hermitage Museum (F601). Photo: Scala / Art Resource [AR], N.Y.

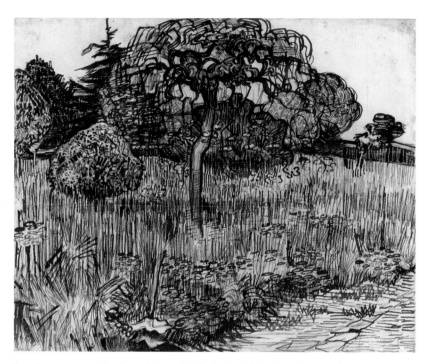

3. Vincent van Gogh, *Weeping Tree*, ca. May 3, 1889. Black chalk, reed pen, and pen
 and ink on paper, 48.9 × 61.5 cm (19¼ × 24¼ in.). Art Institute of Chicago, Gift of
 Tiffany and Margaret Day Blake, 1945.31 (F1468).

this moment in his life? The drawing (figure 3) he described making a week before painting *Irises* and moving to Saint-Rèmy seems more in line with the expression of a man in retreat, of an artist uncertain of himself, his abilities, and his future. The flicker of hope expressed when he writes "It may well be that I shall stay here long enough—I have never been so peaceful as here and in the hospital in Arles—to be able to paint a little at last" (Vincent to Jo, Saint-Rémy, May 10—15, 1889, 591) cannot account for the inescapable vitality that surges off the painting. Although there is clearly a connection between Van Gogh's art and his emotional life, it would be a mistake to consider this painting as a simple barometer of his mood. Despite the abundance of letters between Van Gogh and his brother and friends, he gave very few clues as to how he regarded *Irises*. We will need to explore his surroundings and interests to begin to understand the choices he made in order to achieve what his brother Theo accurately described as "a beautiful study, full of air and life" (Theo to Vincent, Paris, September 5, 1889, T16).

It is rather queer perhaps that the result of this terrible attack is that there is hardly any very definite desire or hope left in my mind, and I wonder if this is the way one thinks when, with the passions lessened, one descends the hill instead of climbing it. (Vincent to Jo, Saint-Rémy, May 10–15, 1889, 591)

For the most part his tone is resigned, even apathetic—except when he mentions the extent to which the work of painting "absorbs" him. Any tentative hope for the future lies in his ability to work; it is his duty, his mission, perhaps even his therapy. Van Gogh turned to painting both as "duty" and as solace. His greatest concern about going to the asylum had been whether or not he would be allowed to paint: "Being locked up and not working, I should find it hard to get better" (Vincent to Theo, Arles, April 30, 1889, 588). When he first arrived his movements were strictly confined to the grounds of the asylum until the doctor had had time to evaluate his health and determine he was well enough to venture out, although he was allowed to work and even given a room to use as a studio.

Now I as a painter shall never amount to anything important, I am absolutely sure of it. Suppose all were changed, character, education, circumstances, then this or that might have been... Today I made a drawing of that sort, which has turned out very dark and rather melancholy for one of spring, but anyhow whatever happens to me and in whatever circumstances I find myself, it's something which will keep me occupied enough and in some fashion might even make me a sort of livelihood. (Vincent to Theo, Arles, May 3, 1889, 590)

Looking at *Irises* it is hard for us to believe that Vincent has not yet, as he claims, regained all his "faculties for work." How do we reconcile the exuberance and confidence we perceive in the image with

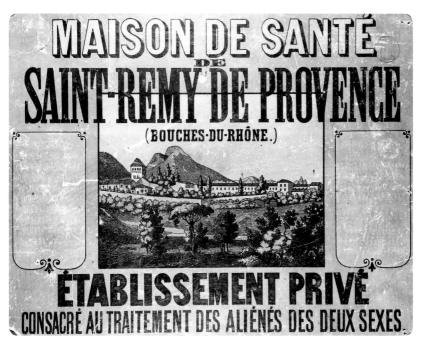

2. Poster showing the asylum (Maison de Santé) at Saint-Rémy-de-Provence. Amsterdam, Rijksmuseum, Vincent van Gogh Library.

I want to tell you that I think I have done well to come here, because, by seeing the reality of the assorted madmen and lunatics in this menagerie, I am losing my vague dread, my fear of the thing. And bit by bit I am getting to consider that madness is just a disease like any other. Thus the change in surroundings will do me good, I think....

The idea of my duty to get back to work occurs to me a lot and I believe that all my faculties for work will soon come back to me. It's just that the work often absorbs me so much that I think that for the rest of my life I will always be a bit absent-minded and awkward when shifting for myself. (Vincent to Theo, Saint-Rémy, May 10–15, 1889, 591)

miles to the northeast. The Protestant minister Reverend Salles, who had assisted him during his illness in Arles, accompanied him. On arrival Vincent voluntarily committed himself to the asylum (Maison de Santé), which was located on the edge of town in the former monastery of Saint-Paul-de-Mausole (figure 2).

> Our journey to Saint-Rémy took place under ideal circumstances. M. Vincent was perfectly calm and explained his case himself to the director, like a man who is fully conscious of his position. He stayed with me until I left and when I said goodbye, he warmly thanked me and appeared somewhat moved by the thought of the entirely new kind of life he was entering in that house. Let us hope that his stay will be truly beneficial for him and that soon he will be regarded as capable of resuming his complete freedom of movement. (Reverend Salles to Theo, Arles, May 10, 1889)[7]

Van Gogh initially planned to stay in the asylum for a few months. His brother Theo urged him not to consider it a "retreat" but simply a "temporary rest cure." In the end Vincent spent a year there. Alone, uncertain, and battling the "vague dread" of his illness, Van Gogh nevertheless began painting within days of his arrival. Two weeks later he wrote that he had exhausted his supply of canvas and paint.

Vincent was given two rooms, a bedroom with a view of a wheat field and a second room that he was allowed to use as a studio. His first letter from the asylum to his brother and new sister-in-law briefly mentions that he had begun work on *Irises* and another painting, *Lilacs*, "two subjects taken from the garden." But much of his letter, which is addressed first to his brother and then to his sister-in-law, Jo, is spent tentatively reassuring them, and perhaps himself, that he had made the right decision and that life would improve.

VINCENT VAN GOGH IN THE GARDEN

JENNIFER HELVEY

THE J. PAUL GETTY MUSEUM LOS ANGELES

For my parents

Published by the J. Paul Getty Museum, Los Angeles

Getty Publications
1200 Getty Center Drive, Suite 500
Los Angeles, California 90049-1682
www.getty.edu/publications

Gregory M. Britton, *Publisher*
Mark Greenberg, *Editor in Chief*

Mollie Holtman, *Editor*
Cynthia Newman Bohn, *Copy Editor*
Catherine Lorenz, *Designer*
Anita Keys, *Production Coordinator*
Louis Meluso, Anthony Peres, Stacey Rain Strickler, *Photographers*
Diane Franco, *Typesetter*

Printed in China through Oceanic Graphic Printing, Inc.

Library of Congress Cataloging-in-Publication Data

Helvey, Jennifer.
 Irises : Vincent van Gogh in the garden / Jennifer Helvey.
 p. cm.
 Includes bibliographical references and index.
 ISBN 978-0-89236-226-4 (hardcover)
 1. Gogh, Vincent van, 1853–1890. Irises. 2. Gogh, Vincent van, 1853–1890—Criticism and interpretation. I. Title.
 ND653.G7A654 2009
 759.9492—dc22
 2009006036

Cover:
Vincent van Gogh (Dutch, 1853–1890), *Irises*, May 1889 (detail). Oil on canvas, 71.× 93 cm (28 × 36⅝ in.). Los Angeles, J. Paul Getty Museum, 90.PA.20.

Note to the Reader
Quotations from, and the numbering and dating of, Van Gogh's letters are taken from the following, except where otherwise noted: Vincent van Gogh, *The Complete Letters of Vincent van Gogh*, 3rd ed., trans. Johanna van Gogh-Bonger and C. de Dood (New York, 2000); letters from Van Gogh to Émile Bernard are from Leo Jansen, Hans Luijten, and Nienke Bakker, *Vincent van Gogh: Painted with Words, the Letters to Émile Bernard*, exh. cat. (New York, Morgan Library, and Amsterdam, Van Gogh Museum, 2007). The numbers included in references to these letters reflect the numbering in these two publications.

Because the titles of artwork by Van Gogh can vary between publications, works discussed here are identified by numbers, beginning with the letter *F*, which refer to those assigned by J. B. de la Faille in his catalogue raisonné *The Works of Vincent van Gogh: His Paintings and Drawings* (Amsterdam, 1970).

CONTENTS

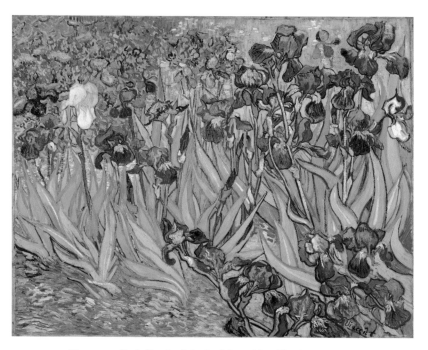

1. Vincent van Gogh (Dutch, 1853–1890), *Irises*, May 1889. Oil on canvas, 71.1 × 93 cm
(28 × 36⅝ in.). Los Angeles, J. Paul Getty Museum [JPGM], 90.PA.20.

CHAPTER 1

AVOIDANCE, SOLACE, AND THE CONTEMPLATION OF NATURE

Vincent van Gogh's *Irises* (figure 1) is one of the artist's most unabashedly beautiful paintings, admired—even beloved—by both casual and committed art lovers. Fantastic ruffled blooms crowd the canvas; green leaves thrust out of the red-orange earth, writhing and waving. *Irises* is an image teeming with life; rather than being cut and artificially arranged, these magnificent flowers remain rooted in the earth, growing, blooming, even seeming to bob as though stirred by a breeze. The painting is a luminous declaration of spring arrived, an enthusiastic display of nature fully, even joyfully, revived in the warmth of the Provençal sun. Van Gogh's easily recognizable, energetic brushwork contributes to the sense of life, highlighting the activity, both physical and intellectual, required to generate this powerful image. Yet how strange and paradoxical the context of the painting's creation may seem in contrast to its mood of insistent vitality. Van Gogh had, just days before commencing the painting of this image, voluntarily committed himself to an asylum for the mentally ill. The now-[in]famous episode in Arles in December of 1888, in which he threatened his fellow painter and housemate Paul Gauguin and subsequently mutilated his own ear, had resulted in repeated hospitalizations. Feeling insecure, he came to doubt his ability to look after himself. These events were an unfortunate and

disheartening denouement to the exciting journey he had embarked upon when he first came to the south of France.

Before this crisis Van Gogh had dreamed of a "brotherhood of artists," a utopian ideal of artists living and working together. Sunny southern France was to provide an inexpensive, inspiring venue for the venture. He arrived in Arles in February 1888 full of plans and determination, telling his brother Theo in March that "I feel as though I am in Japan"—a place which had for Van Gogh an exotic allure that was colored by his own perceptions of its cultural ideals. In late October 1888, his dream of an artistic cooperative seemed about to be realized. With Theo's financial support, Paul Gauguin finally agreed to join Vincent in his yellow house. In enthusiastic preparation, Van Gogh decorated the room intended for Gauguin with his paintings of sunflowers. Although productive and stimulating, collaborating with Gauguin was also stressful and increasingly contentious. When planning for their eventual artistic success, Van Gogh had held Gauguin's abilities in such high respect that he viewed him as the senior artist who would act as the head of their studio: "There must be an abbot to keep order, and that would naturally be Gauguin...Do you realize that if we get Gauguin, we are at the beginning of a very great thing, which will open a new era for us" (Vincent to Theo, Arles, October 3, 1888, 544). But once they were living and working together, Vincent was surprised to find that they disagreed—at times heatedly—on many points of art theory. Gauguin quickly tired of the living arrangements and the provincial location, and by mid-December, just two months later, he began to contemplate leaving. In addition to this imminent defection, Vincent received the news of the engagement of his brother Theo, on whom he depended for financial and emotional support.[1] On December 23/24, 1888, Vincent suffered his dramatic mental episode. Theo came to town to check on him but had to return to his job in Paris the next day, taking Gauguin with him.

Vincent, still confused and injured, was left alone in the hospital in Arles to recover physically and mentally. His friend Roulin the postman was transferred to Marseilles the following month. During the ensuing months Van Gogh suffered three more episodes and was in and out of the hospital. His sometimes irrational behavior alarmed the locals, and a movement was made to have him committed (or ejected from the town). To make matters worse, a flood damaged his home and studio. At the end of April, as he was packing up what was left of the contents of his studio and considering a stay at the asylum at Saint-Rémy-de-Provence, he wrote to his brother Theo.

> [The flood damage] was a blow to me, since not only the studio had come to grief, but even the studies that would have been reminders of it. It is all so final, and my urge to found something very simple but lasting was so strong. I was fighting a losing battle, or rather it was weakness of character on my part, for I am left with feelings of deep remorse about it, difficult to describe. I think that was the reason I cried out so much during the attacks—I wanted to defend myself and couldn't do it. For it was not to me, it was precisely to painters such as the poor wretch about whom the enclosed article speaks that the studio could have been of use. (Vincent to Theo, Arles, April 30, 1889, 588)

In choosing to go to the asylum, Vincent had to contend not just with the knowledge of his debilitating illness, for which there was no definite prognosis or known cure,[2] but also with his feelings of defeat and loss.

This was not the first time that Van Gogh had experienced the failure of dreams, dissolution of friendships, isolation, and even abandonment. He had numerous stops, starts, and disappointments in his life before deciding to become an artist. Born in 1853, Vincent Willem

van Gogh was the first surviving child of Anna van Gogh-Carbentus and the Reverend Theodorus van Gogh, a preacher in the Dutch Reformed Church. He and his siblings—two brothers, Theodorus (Theo) and Cornelis (Cor), and three sisters, Anna, Elizabeth (Lies), and Wilhelmina (Wil)—were raised in a deeply religious household which venerated a life that emulated Christ through humility and service. The world of art was never, however, far away; three of Vincent's paternal uncles worked as art dealers, and art was considered a powerful teaching tool within the religion in which he was raised. Sent to boarding school in 1864, he grew homesick and left during his second year. In 1869, his Uncle Cent arranged a position for fifteen-year-old Vincent as a clerk at The Hague branch of Goupil, a Paris-based international art dealership that sold original art and also had a booming business in photographic and printed reproductions. In 1873, Vincent moved to Goupil's office in London, where, while he experienced some reasonable success in business, he also experienced his first unrequited love. In May 1875, he was moved to the Paris branch, but in 1876 his increasing disdain for treating art as a commodity and his growing religious awakening led him and his employers to agree to end his employment. Although Van Gogh was clearly fascinated with and moved by art—he visited museum collections and read artist biographies—he had determined that his true calling was to be a minister.

His father insisted that he show real commitment by taking the required schooling (a seven-year program) in Amsterdam—which Vincent failed to complete. He tried again at a three-year mission school outside of Brussels but did not last the ninety-day probationary period. Giving up on institutional education, he took a position ministering to miners in the Borinage region of Belgium. His commitment to living like the poor he served led to some extreme behavior that disturbed the sponsoring organization, and they dismissed him. He stayed in the Borinage and continued to struggle on his own

for a year. His father, alarmed and no doubt frustrated, appears to have seriously considered entering him in a facility for the mentally ill. Not surprisingly, these plans caused a significant rift with his family, and Vincent stopped corresponding with them for a year.

His brother Theo, himself then working for Goupil, renewed familial contact with Vincent. Theo eventually suggested that he seriously pursue a career as an artist and began sending him money in support of that goal. Although his education and work attempts had focused on religion and service, Van Gogh's reading material, which included catalogs of collections and biographies of artists, had always incorporated the study of art. In 1880, he went to Brussels to study anatomy and drawing at the Royal Academy of Art. In 1881, he returned to live with his parents in Etten and began to work on his own—and once again fell victim to unrequited love. After yet another argument with his father, Vincent went to live in The Hague, where he took lessons with his cousin Anton Mauve, a successful artist. This relationship was soon disrupted, apparently by Mauve's disapproval of Van Gogh's cohabitation with a pregnant prostitute and her child. That relationship, too, soon ended, but Vincent made progress in developing his artistic skills; his uncle Cor commissioned a series of twelve views of The Hague in watercolor.

In the autumn of 1883, Van Gogh moved again, this time to Drenthe, a northern Dutch province, which had an active artist community connected with The Hague.[3] Feeling lonely, in December he moved south to stay with his parents, who were now living in Nuenen. A love affair with a neighbor's daughter had disastrous results; both families were opposed to their marrying, and she attempted suicide. Despite this setback in his personal life, Van Gogh continued his pursuit of a career as an artist. Seeking to blend his charitable impulse to serve the poor and his artistic ambitions, Vincent resolved to be a painter of peasant life, like his artist-heroes Jean-François Millet

(1814–1875) and Jules Breton (1827–1906). He continued to sketch and paint, but some narrow-minded members of the local clergy, suspecting him of immoral intentions rather than purely artistic purposes, impeded his ability to find models by telling him that he "ought not be too familiar with people below him in station"[4] and even warning away the members of their congregations. Painting in a dark palette, he completed his first major work, *The Potato Eaters*, but was disappointed when Theo was unsuccessful in his attempts to sell the painting. When Vincent complained, Theo tried to explain that Parisian collectors were more interested in the colorful works of the Impressionists. Criticism of the painting from his good friend and fellow artist Anton Rappard caused Vincent to end what had been an important friendship. The loss of his father to a stroke in March 1885 left him both grief-stricken and relieved. The following November he moved to Antwerp, where he visited the public painting collections, began acquiring Japanese woodblock prints, and enrolled (for just two months) at the École des Beaux-Arts.

In February 1886, Vincent decided to join Theo in Paris, on his arrival leaving a note that he was in town and Theo could find him at the Louvre. Vincent worked rapidly to assimilate the wide variety of art available in Paris and to develop his own style. He met and exchanged ideas with many avant-garde artists, including Émile Bernard, Paul Gauguin, Camille Pissarro, and Paul Signac, and took classes alongside Henri de Toulouse-Lautrec, among others, at the studio of Fernand Cormon. He soon radically lightened his palette and began experimenting with broken brushwork and the juxtaposition of pure color in response to the work of the Impressionists and the Pointillists. His exposure to Japanese art expanded through contact with other similarly enthusiastic artists and collectors. Particularly influential was his access to the Japanese objects of the dealer Siegfried Bing (1838–1905), from whom Vincent and Theo acquired

more prints and in whose shop and storeroom the artist spent many pleasurable hours. He continued to be an avid reader and was able to add journals and books about Japan and its art and culture to his "diet" of French naturalist literature and philosophy. He took full advantage of the opportunities to see art at the contemporary art dealers, public exhibitions, and public collections, including the Musée de Luxembourg. He arranged his own exhibition at a café. But home life with Theo was not always comfortable; the brothers argued, and Vincent was at times disagreeable and difficult.

In February 1888, exhausted by urban life, Van Gogh moved alone to Arles in the south of France. There he hoped to establish a studio, not just for himself but also for a community of "brother" artists.[5] Vincent reveled in the rural landscape and strong light of the south, and this resulted in one of the most productive and iconic periods of his career. But the dream ended in the debacle of his breakdown and hospitalization. Just as it seemed arrangements had been settled for him to live and work quietly in another part of town, Vincent himself concluded that he was incapable of taking care of himself and chose to enter the asylum in Saint-Rémy. Despite further episodes of debilitating mental illness, during his periods of lucidity Van Gogh continued to paint, producing some of the masterpieces for which he is most famous, including *Irises* and *Starry Night*. Following a year in the asylum, Vincent moved to Auvers-sur-Oise, which placed him in closer proximity to Theo in Paris. At the recommendation of Camille Pissarro, he was under the care there of Dr. Paul Gachet, a doctor, homeopath, and amateur painter. During a visit with Vincent in July 1890, Theo, suffering from his own serious health problems and now bearing the responsibilities of a husband and father, expressed concerns about his own work and their financial situation.[6] Toward the end of that same month, Vincent went into a wheat field and shot himself in the chest. He returned to the inn where he was

living, refused medical treatment, and died two days later with Theo by his side. Theo returned to Paris and staged a memorial exhibition in September, only to die himself in January 1891.

❖ ❖ ❖

In our modern-day mythology, Van Gogh is the iconic misunderstood, unappreciated, and doomed artist-genius, resistant to class or patriarchal constraints, undeterred by his lack of financial or critical success, alone and struggling to retain his sanity, and ultimately dedicated only to his art. Van Gogh's reality was far more complex than this legend, but in his long battle to find his way in life and art, the point at which he surrenders his physical freedom, acknowledges his weakness, and enters the asylum is noteworthy. At that moment, this intense, stubborn individual, who appears to have undertaken every enterprise with a nearly heedless exuberance, hesitates and is uncertain of himself and his future.

> So now here's for Saint-Rémy. But I tell you once more, if on consideration and after consulting the doctor it should perhaps be either necessary or simply advisable and wise to enlist [in the Foreign Legion], let's give it the same consideration as everything else and have no prejudice against it . . . And now I am packing my trunk, and probably M. Salles will go over with me as soon as he can . . . I have a sort of hope that with what on the whole I know of my art, the time will come when I shall produce again, even in the asylum. (Vincent to Theo, Arles, May 3, 1889, 590)

With some real trepidation—evidenced by his offer of five years in the Foreign Legion as a viable option—Van Gogh boarded a train in Arles on May 8, 1889, bound for the city of Saint-Rémy, just fifteen

CHAPTER 2

THE IRIS AS SUBJECT

I am working on two others—some violet irises and a lilac bush, two subjects taken from the garden. (Vincent to Theo, Saint-Rémy, ca. May 10–15, 1889, 591)

Since I have been here, the deserted garden, planted with large pines beneath which the grass grows tall and unkempt and mixed with various weeds, has sufficed for my work, and I have not yet gone outside. (Vincent to Theo, Saint-Rémy, May 25, 1889, 592)

Irises was begun within days of Van Gogh's arrival in Saint-Rémy; he wrote in his first letter from the asylum to Theo describing his two subjects—irises and lilacs. Why irises? The simplest answer is that they were there, blooming and available in the walled garden and on the grounds to which he was initially confined. In this neglected space, irises appear to have grown with enthusiasm. In *Lilacs* (figure 4), the other "subject taken from the garden" he mentions in his first letter, clumps of irises appear at the base of the lilac bush, another plant that blooms in early to mid-May, and again along the path at right. They also appear in the lower left of a drawing of the "southwest corner of the walled garden, where the entrance to the complex is situated,"[8] *A Corner in the Garden of Saint-Paul's Hospital at*

5. Vincent van Gogh, *A Corner in the Garden of Saint-Paul's Hospital at Saint-Rémy*, last week of May–first week of June 1889. Reed pen, pen, brush, and ink, and graphite on pink laid paper, 62.2 × 48.3 cm (24½ × 19 in.). London, Tate Gallery, Bequeathed by C. Frank Stoop 1933, N04716. Photo: AR, N.Y.

Saint-Rémy (figure 5). The parklike garden was reasonably large and there were many things to paint, as he did over the ensuing year; he began with irises and lilacs, which would soon fade.

> Since it is just the season when there are plenty of flowers and conse-quently color effects, it would perhaps be wise to send me another five meters of canvas. For the flowers are short-lived and will be replaced by the yellow wheat fields. (Vincent to Theo, Saint-Rémy, ca. June 2, 1889, 593)

Van Gogh enjoyed painting flowers; he admired the work of contempo-rary flower painters like Adolphe Monticelli (1824–1886) and Ernest Quost (1844–1931). Flowers were considered a decorative, easily mar-keted subject, and Vincent constantly hoped for commercial success as an artist.[9] In addition to being an attractive subject to buyers, flowers offered a range of colors to study and, when cut, were easily composed; he had used bouquets of flowers as his subjects while he was expand-ing and experimenting with his palette during his time in Paris. In Arles, having completed his famous series of sunflowers in vases, Vin-cent rightly stated that he felt that he had made that flower his own.

When Van Gogh wrote of flowers, he often did so in terms of color arrangements.

> But I have made a series of colour studies in painting, simply flowers, red poppies, blue corn flowers and myosotys, white and rose roses, yellow chrysanthemums—seeking oppositions of blue with orange, red and green, yellow and violet, seeking *les tons rompus et neutres* to harmonize brutal extremes. Trying to render intense colour and not a grey harmony. (Vincent to Horace M. Livens, in English, Paris, August/October 1886, 459a)

He was particularly interested in the concept of complementary colors, which he had learned of earlier in studying the writings of the Romantic painter Eugène Delacroix (1798–1863) and Michel Chevreul (1786–1889), a professor of organic chemistry, an optical theoretician, and director of the dyeing department of the Gobelins tapestry factory. In a letter of 1885 to Theo, Vincent quoted Delacroix at length.

If one combines two of the primary colours, for instance yellow and red, in order to produce a secondary colour—orange—this secondary colour will attain maximum brilliancy when it is put close to the third primary colour not used in the mixture. In the same way, if one combines red and blue in order to produce violet, this secondary colour, violet, will be intensified by the immediate proximity of yellow. And finally, if one combines yellow and blue in order to produce green, this green will be intensified by the immediate proximity of red. (Vincent to Theo, Nuenen, ca. April 13–17, 1885, 401)

The effect of one color laid next to another to achieve greater brilliance or luminosity, which Chevreul called "the law of simultaneous contrast," was of great importance to Van Gogh. He conducted his own investigations of color theory by studying the relationships between different-hued strands of yarn (a container of balls of yarn owned by the artist is preserved today in the Van Gogh Museum).[10] Throughout his letters he referred to the pairings of colors within paintings, as well as across pairs of paintings: "A bunch of orange tiger lilies against a blue background, then a bunch of dahlias, violet against a yellow background" (Vincent to Theo, Paris, August 1886, 460). In Chevreul's *Principles of Harmony and Contrast of Colours*, first published in 1839 and read by Van Gogh in 1884–85,[11] the author discusses the application of his theories of color and simultaneous contrast not

just to painting but also to architecture, interior design, clothing, horticulture, and more. He even recommended felicitous arrangements of flowers for the month of May, massing white and blue irises together but adjuring against a "linear association" of irises and lilacs, for "nothing is more unpleasant than the blue flowers of the German iris associated with the light violet of the lilac."[12] The combinations of orange and blue, and violet and yellow, which demonstrate Chevreul's law of contrast, are repeatedly mentioned in Van Gogh's letters. He also employed them in the first two paintings of the asylum garden, *Irises* and *Lilacs*, in which the play of color relationships follows the pattern described by Delacroix and Chevreul. In the first painting, blue blooms and green (combining yellow and blue) leaves are placed against orange blooms (of the flowers in the background) and red earth. The green of leaves and grass dominates *Lilacs*, but the painting also pairs the violet of the lilacs with yellow grasses.

That Van Gogh not only read Chevreul's work but also engaged in testing the theories in yarn and paint seemingly runs counter to popular perceptions that the artist painted from his heart, his instinct, or his imagination, or that his highly personal vision stemmed from his illness. But in the nineteenth century, the elision of the subjective and the objective was hardly uncommon; rather it was a critical aspect of broader developments in science, philosophy, and the arts. Chevreul extended his optical observations into the realm of aesthetics, while Jules Michelet (1798–1874), a historian whose writings greatly influenced Van Gogh, wrote books in which natural history was transformed into both poetry and a personal, pantheistic philosophy. Many writers have discussed the paradoxes that lay at the root of the Impressionists' efforts. Inspired by new scientific theories of vision and perception, these artists attempted to objectively reproduce the experience of light and color on the retinas of their eyes, knowing that their results were inevitably

subjective, restricted to the personal observation and optical organs of the artist.[13] Many of Van Gogh's close associates, including Paul Gauguin and Émile Bernard, were dissatisfied with this positivist approach, which gave priority to objective observation, and sought instead a renewal of a more spiritual notion of "vision." While Van Gogh upheld a belief that art could and even had a duty to express a "deeper" reality, he also maintained that he was committed to naturalism. The dialectical pull (if one considers the observation and depiction of nature to stand in opposition to the expression of things emotional, spiritual, or philosophical) within Vincent's work in many ways gives it its greatest power. Vincent achieved in *Irises* at least one of the ends he pursued in composing pictures of orange/red and blue: *Irises* has a luminosity and intensity of color that gives life to the plants he depicted and suggests the brilliant Provençal sun under which they grew. Whether he equated that luminosity and life with emotions such as hope, fervor, or anxiety is more elusive.

> Why did the greatest colorist of all, Eugène Delacroix, think it essential to go South and right to Africa? Obviously, because not only in Africa but from Arles onward you are bound to find beautiful contrasts of red and green, of blue and orange, of sulphur and lilac. (Vincent to Theo, Arles, September 17, 1888, 538)

❖ ❖ ❖

Iris is a term for a genus of plant with nearly three hundred species. They can be found flourishing around the world, though primarily in the northern hemisphere, in a variety of shapes and colors and in varied climates. The plants blooming in the garden in Saint-Rémy belong to a group known as tall bearded irises—a *beard* being a tuft or row of longish hairs at the top of the falls (the lower petals). The leaves

are broad, frequently described as swordlike, and sometimes twist as they bend away from the center of the plant. The blooms are generally large and fleshy, with six often beautifully ruffled petals, three curving up (standards) and three bending down (falls). Carl von Linné (Carolus Linnaeus), the "father of taxonomy," gave the bearded irises their name, *Iris germanica*, in 1753.[14] The bearded irises's ubiquity caused some early naturalists to call it *Iris vulgaris*. The most common color of *Iris germanica*—and the one Vincent paints here—is violet-blue (figure 6). Nigel Service, a specialist in irises, suggests that they may even be the "bluest of all *I. germanica* forms, *caerulea*,"[15] which he notes is peculiar to that small area of southern France in which Saint-Rémy is located. *Iris germanica* is a natural hybrid,[16] quite hardy, which can flourish even untended, as it seems were the plants in the overgrown "deserted" asylum garden.

6. *Iris germanica*, photographed by Clay Perry, London. Photo: © Clay Perry.

The single white bloom in *Irises* (figure 7) may be one of two varieties of iris. *Iris albicans* (figure 8),[17] originally known as *Iris florentina*, was for centuries raised and prized for its root (orris), which was used in the making of perfume. The other candidate for Van Gogh's single white bloom would be the flower now identified as *Iris florentina*, or more specifically *Iris germanica var. 'Florentina' Dykes* (figure 9). It seems that *Iris albicans* did not thrive in England, where much of the taxonomy of irises was established in the late nineteenth and early twentieth centuries, and some confusion arose and remains.[18] *Iris 'Florentina'* tends to have a bluish cast with a more prominent yellow beard, while *Iris albicans* is generally more pure white. "*'Florentina'* has falls (the three lower petals) that are a bit more droopy and elongated than *I. albicans*."[19] The easiest way to distinguish *I. 'Florentina'* from *I. albicans* is by the difference between their bracts, the leaflike structure that envelops the flower in the bud phase. *I. 'Florentina'* has bracts that are "almost wholly

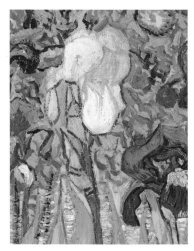

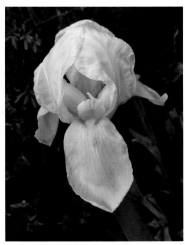

7. Detail of *Irises* (figure 1).

8. *Iris albicans*, photographed by Jorge Moura, Portugal. Photo: © Jorge Moura.

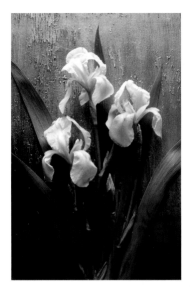

9. *Iris germanica 'Florentina,'* photographed by Clay Perry, London. Photo: © Clay Perry.

brown and papery at flowering time,"[20] while those of *I. albicans* are very broad, blunt, and "green or purplish tinted in the lower half or two-thirds and papery-transparent in the upper part."[21] Unfortunately, the bracts on the fully blooming white flower are not visible. *I. albicans* bears secondary, lateral sessile blooms (flowers that spring directly from the stalk below the primary bloom), while *I. 'Florentina'* "is branched, with branches that are quite long, immediately distinguishing it from *I. albicans*."[22] Although in Van Gogh's painting the color of the bracts is inconclusive for our purposes, there are quite clearly two buds swelling directly on the stalk below the white bloom but no visible lateral branching. While as an artist Van Gogh had the option to be free with color and form, he does seem to have been rather consistently attentive to detail when it came to flowers, making it more likely that the flower depicted is indeed *I. albicans*. The prevalence of *I. albicans* in southern France

as a crop used in its important perfume industry encourages this identification as well. There is, however, a third alternative: on very rare occasions, *I. germanica* may produce a *sport*, a somatic mutation (occurring in the nonreproductive cells of an organism) that creates blooms of a different color.[23] But even a sport of *I. germanica* should produce branching, and that is not apparent here. Ultimately, *I. albicans* is identified by the "poise and shape of the flower,"[24] and it is this "essence" that Van Gogh has captured on his canvas.

The great flower illustrator Pierre-Joseph Redouté depicted the flower we now call *Iris albicans* (as *Iris florentina*), as well as the blue *Iris germanica*, in his renowned series entitled Les Liliacées, originally painted in watercolor on vellum for the Empress Josephine in 1802 (figures 10 and 11). Redouté's flowers, grouped by genus, observed and depicted with precision, might be seen as the visual equivalent of Linnaeus's written catalogue. Though they are beautifully arranged and rendered, each bloom is laid out almost as if it were a specimen on a slide in the tradition of earlier botanical illustrations. The implicit goal is identification first, delectation second. Van Gogh's irises, in contrast, remain in their natural, rather chaotic state. They lean, crowd, and push forward, rather like children posing for a group photograph. Instead of being representations of a genus or species, Vincent's irises are themselves—*these* living plants, *these* blooms, *this* garden, *this* moment.

> Perhaps you will tell me that every work of art must of necessity be the result of a great number of complicated combinations. This is true, but for the painter too there must come moments when he is so inspired by his subject or theme that he renders it in such a way that one can know, or at least feel, it like a thing you are simply confronted with. I feel this when I stand before many of your canvases. (Theo to Vincent, Paris, November 16, 1889, T20)

Irises have long been popular cultivated plants. The ancient Greek taxonomer Theophrastus named them after Iris, nymph/goddess and messenger to the gods, who traveled by means of a rainbow. The Greek physician and botanist Dioscorides listed *Iris* [*germanica*] under "Aromatics" and claimed that it is "named . . . for the varietie of colours it is likened to the heauenly rainebow."[25] We are accustomed to thinking of irises (and perhaps flowers in general) as merely decorative, but for centuries they had many uses. Dioscorides described how to dry the orrisroot for aromatic and medicinal purposes. Pliny gave instructions on where and how to collect the plants. In the Middle Ages, irises were a popular addition to gardens. "The petals of the dark blue iris made a green pigment for medieaval painters; iris roots made a perfume (orris root); when 'drunken with wine or ale' it could destroy wicked humors in a man's breast and the cough."[26] The medicinal use of orrisroot as a cathartic and a purgative continued, though the practice was waning, into the nineteenth century. Small pieces of iris root, called *Pois d'iris* or *issue-peas*, were inserted into wounds to encourage the production of discharge.[27] Orrisroot was ground to produce tooth powder, and dried, shaped roots were given to infants to relieve the pain of teething. An author writing in 1907 claimed that irises had long been used medicinally for rabies and in calming anger or rage, and that in certain parts of Brittany and the Vendée, *Iris germanica* was known colloquially as *herbe à la rage* and *passe-rage*.[28] The possibility that the iris plant offered a potential herbal remedy for Van Gogh's illness makes it an interesting choice of subject and adds an unexpected dimension to his belief that nature and the activity of painting nature was therapeutic and beneficial to his mental health.

By far the most common use for irises has been in the production of perfume, both for their scent and as a fixative. The flower's violetlike fragrance was extremely popular in the nineteenth

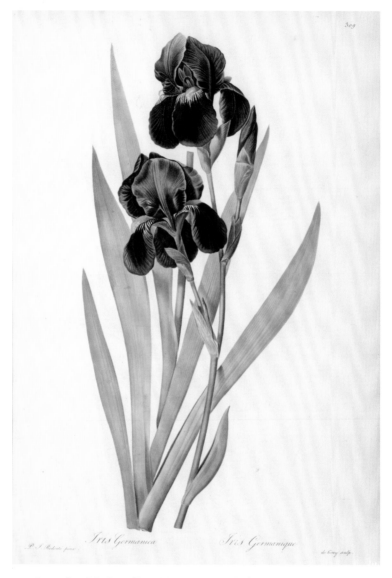

Iris Germanica *Iris Germanique*

P. J. Redouté pinx.

de Gouy sculp.

10. Pierre-Joseph Redouté (French/Belgian, 1759–1840), *Iris germanica*, plate from Les Liliacées (Paris, 1802–16). New York Botanical Garden, LuEsther T. Mertz Library. Photo: AR, N.Y.

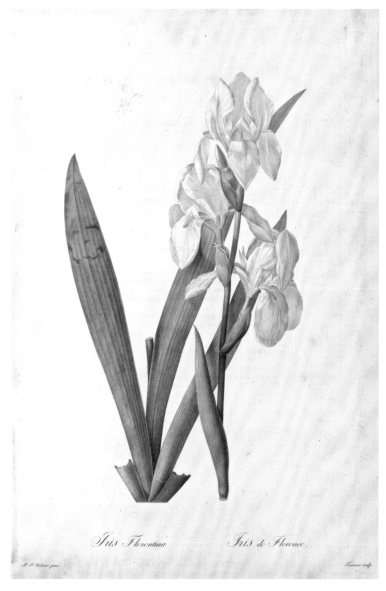

Iris Florentina *Iris de Florence*

11. Pierre-Joseph Redouté, *Iris florentina*, plate from Les Liliacées. New York Botanical
Garden, LuEsther T. Mertz Library. Photo: AR, N.Y.

century. Linens were washed and stored with orrisroot. The naturalist novelists, whose work Van Gogh read and enjoyed, employed orrisroot among the smells and odors that described their world. In *La Terre* (1887), Émile Zola described the tragic Lise as she agreed to consider Jean's marriage proposal: "Her whole person, soaked in warm steam, had a smell of good housewifery, a smell of bleach and orris root."[29] For Alphonse Daudet, a Provençal novelist whom Van Gogh admired, the scent of orris represented a boy's protective memory of his mother, "a radiant and fragrant vision, as if some fairy had come down to him in an orris-scented cloud."[30] In the same novel, when the titular hero's betrothed displays her trousseau, "the two doors swung back and a delightful odour of fresh-washed clothes and orris floated forth."[31] For Guy de Maupassant and Gustave Flaubert, the scent of orris had more to do with feminine mystique and illicit romance than with comfortable or efficient domesticity. In Flaubert's *Sentimental Education* (1869), Frédéric has only a glimpse of Madame Dambreuse, but "there drifted a perfume of orris, an indefinable scent of feminine elegance."[32] In Maupassant's *Bel-Ami* (1885), Duroy, "having paused to allow a perfumed lady to alight from her carriage and enter her house, [...] drew in with eager breath, as she passed him the scent of verbena and orris floating in the air. His lungs and heart throbbed suddenly with hope and joy, and the recollection of Madame de Marelle, whom he was to see the next day, came vividly to mind."[33] More morbidly, in Maupassant's short story "The Grave," the man's memory of the orris-perfumed bed of his deceased lover contrasts sharply with his encounter of the stench of her putrefying corpse. In a more populist combination of feminine elegance and domestic activity, the August 18, 1888, issue of *Good Housekeeping* gave instructions for making perfumed sachets of silk or cheesecloth filled with orrisroot to place in a lady's handkerchief box.

The plant above the ground also had its place in European literary and visual culture. At one time considered a type of lily, to which they are related, irises have also been called variously *gladiolus* (sword-lily in Latin),[34] *Schwertlilie* (sword-lily in German), and *flag*, as well as *flour-de-lice* or *flower-de-luce* in English, probably derived from the French *fleur-de-lis* or *fleur-de-lys* (flower of the lily). Émile Littré, in his *Dictionnaire de la langue française* (Paris, 1877), defined *flambe* (also *flamme* in some regions) as a common name for *Iris germanica* as well as other irises of marshy regions, presumably for the flame-like shape of its blooms. The tripartite shape of the iris is thought to have been the original source for the fleur-de-lis,[35] symbol of French royalty. An iris today may seem an innocuous, elegant ornament, but during the French Revolution, "it was proscribed and anyone found wearing the flower went to the guillotine."[36] The original white *Iris florentina* (*la flambe blanche*), not surprisingly, appeared on the arms of the city of Florence. The common practice of planting irises, particularly white irises, on graves may explain their wide distribution and popular cultivation. *Iris albicans*, still sometimes referred to by gardeners as white cemetery iris, was long thought to have been carried by the Moors into Europe to plant on the graves of fallen soldiers.

The *flower-de-luce* appears from the sixteenth century onward in a wide range of English poetical works, including those of Shakespeare (*A Winter's Tale*) and Edmund Spenser (*The Faerie Queen*). In the nineteenth century, English and American poets continued to use the term *flower-de-luce* instead of iris as a quaint poetic device; Oscar Wilde employed it for a crown of spring flowers in his "Humanitad" (1881), and Henry Wadsworth Longfellow, whose work Van Gogh enjoyed, wrote a poem entitled "Flower-de-Luce" containing these lines:

> Born in the purple, born to joy and pleasance,
> Thou dost no toil nor spin,

But makest glad and radiant with thy presence
The meadow and the lin. . . .
O flower-de-luce, bloom on, and let the river
Linger to kiss thy feet!
O flower of song, bloom on, and make forever
The world more fair and sweet.[37]

Described in these poems as a noble, stately flower, irises were most frequently a harbinger of spring, a messenger of hope, joy, and beauty.[38] But "Iris" often appeared in eighteenth- and nineteenth-century French literature as a woman's name, frequently that of a lamentably fickle, anonymous object of desire. A quatrain which appeared on Charles-Nicolas Cochin's print of *Iris* by Jean-Antoine Watteau (1684–1721) gave that painting its name.

Iris, aren't you young to have a feel for the dance,
As knowingly you make gentle movements,
Which daily remind us by their cadence,
Of the taste of the fair sex for instruments?[39]

The practice continued in the nineteenth century; one of Van Gogh's favorite authors, the historian-philosopher Jules Michelet, employed the name Iris to stand for young desirable females: "The love which boys bear for a white and rosy Iris of fifteen can hardly be called love; it is a surface desire, a slight arousing of the senses."[40] Michelet, like many other writers, used flowers more generally as a metaphor for women. In his treatise entitled *La Femme*, he wrote: "Women are much more natural, and very diverse . . . Are they plants, flowers? Yes—living flowers, a marvelous iris of exquisite lives, seemingly fluid, but organized—moving, active, having volition."[41] This trope of the woman-flower became so prevalent

that it was parodied in *Les Fleurs Animés* (1847), written by Taxile Delord and amusingly illustrated by J. J. Grandville, in which flowers become women, each representing a quality typically associated with the bloom in the Victorian language of flowers. The fashionable parlor books of flower language, which variously took a frivolous or moralizing tone, continued in popularity until the end of the nineteenth century.

Van Gogh was hardly the first European painter to take irises as his subject. Medieval and Renaissance painters included them in Christian religious works, primarily in depictions of the Annunciation or the Virgin and Child; perhaps the best examples are in the Portinari Altarpiece (figure 12) by Hugo van der Goes (d. 1482) and in Leonardo da Vinci's *Madonna of the Rocks* (figure 13). But irises also appear in the works of Hans Memling, Rogier van der Weyden, and Albrecht Dürer, among numerous others. These artists and their contemporaries believed that the natural world provided reminders of and testimony to the power and nature of divinity: flowers, herbs, insects, and other natural details in a painting were there not just to beautify the image but also to convey more complex religious concepts.[42] The iris's double tripartite form could suggest a subtext regarding the Trinity. Likewise, the sword-shaped leaves of the sword-lily often presaged the coming sacrifice and pain of the Virgin and Christ; it is the "sword that pierces the heart of the Mater Dolorosa."[43] Influential religious figures Bernard of Clairvaux (1090–1153) and Saint Bridget (1303–1373), both central to the development of the Marian cult, emblematically compared Mary to the sword-lily. Bridget emphasized "the height of the plant and the high calling of Mary, and [said] that its blade-like leaf, which splits in two, should remind us of the Blessed Virgin who was also split 'with the pain in her heart for the sorrows of her Son, and her determination to fight off the Devil.'"[44] Elsewhere, irises have been interpreted more

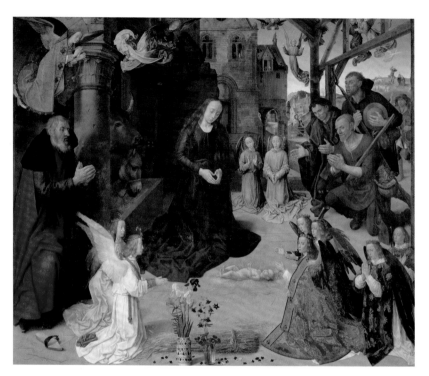

12. Hugo van der Goes (Flemish, ca. 1440–82), *The Adoration of the Shepherds*, central panel of the Portinari Altarpiece, ca. 1479. Tempera on wood panel, 2.53 × 3 m (8 ft. 3½ in. × 9 ft. 10 in.). Florence, Galleria degli Uffizi, 3191. Photo: Erich Lessing / AR, N.Y.

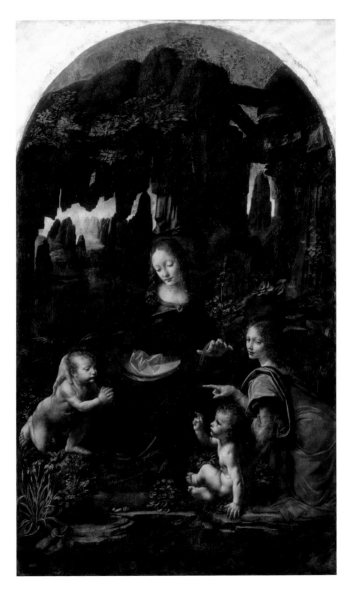

13. Leonardo da Vinci (Italian, 1452–1519), *The Madonna of the Rocks*, ca. 1483. Oil on panel, 1.99 × 1.22 m (6½ × 4 ft.). Paris, Musée du Louvre, 777. Photo: Hervé Lewandowski / Réunion des musées nationaux [RMN] / AR, N.Y.

generally, though usually again in some relation to the Virgin Mary, as a symbol of purity or suffering.[45]

The iris continued to bear religious undertones into the seventeenth century in Dutch flower painting. Spectacular bouquets of cultivated flowers could be read moralistically or religiously, with an iris included as a Marian or pious reference. But these paintings were also enjoyed for their display of sheer horticultural beauty, just as the iris has long been exploited for its decorative qualities. Jan Brueghel the Elder included two varieties of iris in addition to other flowers, such as roses and the much admired tulip, in his *Flowers in a Stoneware Vase* (figure 14), and, more than a century later, Jan van Huysum placed a blue Dutch iris in the lower center of his *Fruit Piece* (figure 15). There was no shortage of irises in the long tradition of flower painting, which continued in France in the nineteenth century. Henri Fantin-Latour combined May-blooming peonies and irises in his still life *Bouquet of Peonies and Irises* (figure 16). Paul Cézanne, also painting in Provence in 1889–90, included irises in his *Blue Vase* (figure 17), though curiously, not the local bearded irises.

Pre-Raphaelite and British painters also employed irises in their work, not just for their decorative qualities but also from an interest in medieval/Renaissance art and associations, as well as in Victorian flower language. In *Fair Rosamund* (figure 18), Arthur Hughes—a painter given to medievalizing, romantic subjects—planted irises directly in front of his main character, King Henry II's doomed mistress who is about to be murdered by the jealous queen. With her green skirts and violet bodice echoing the form of the blooming plant at her feet, Rosamund becomes a flower, an iris, in the walled garden where the king has sequestered her.[46] What precisely does the iris mean in this context? In flower language "dictionaries," the iris is defined most frequently as simply *message*, which does not seem to apply to Rosamund. But Rosamund's name comes

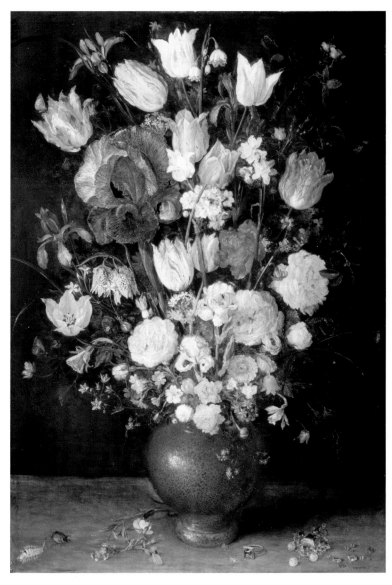

14. Jan Brueghel the Elder (Flemish, 1568–1625), *Flowers in a Stoneware Vase*, ca. 1608.
Oil on panel, 58.3 × 41.9 cm (23 × 16½ in.). Cambridge, Fitzwilliam Museum, PD.20-
1975. Photo: Bridgeman Art Library [BAL].

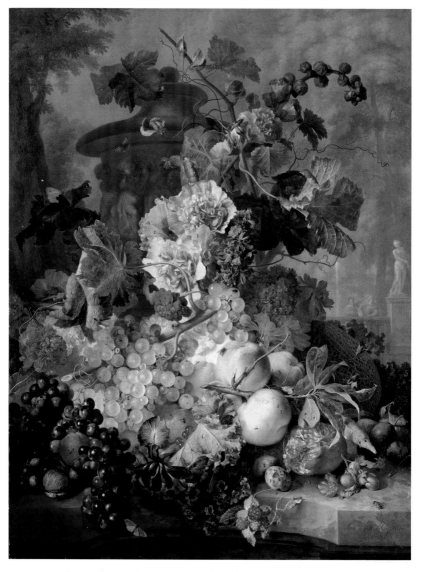

15. Jan van Huysum (Dutch, 1682–1749), *Fruit Piece*, 1722. Oil on panel, 79.4 × 61 cm
(31¼ × 24 in.). Los Angeles, JPGM, 82.PB.71.

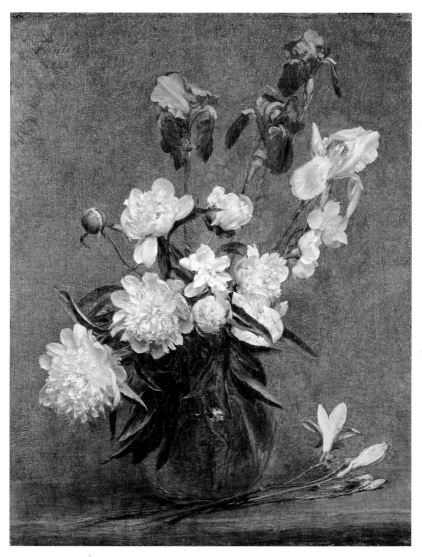

16. Henri Fantin-Latour (French, 1836–1904), *Bouquet of Peonies and Irises*, 1883.
Oil on canvas, 61 × 48 cm (24 × 18⅞ in.). Private collection. Photo: BAL.

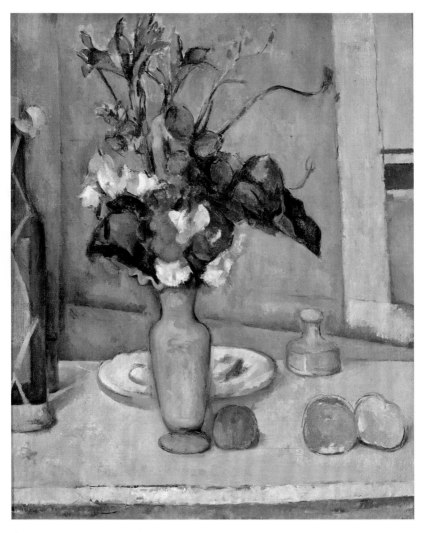

17. Paul Cezanne (French, 1839–1906), *The Blue Vase*, 1889–90. Oil on canvas,
62 × 51 cm (24³⁄₈ × 20¹⁄₈ in.). Paris, Musee d'Orsay. Photo: Erich Lessing / AR, N.Y.

18. Arthur Hughes (English, 1832–1915), *Fair Rosamund*, 1854. Oil on wood panel,
40.3 × 30.5 cm (15 7/8 × 12 in.). Melbourne, National Gallery of Victoria, Gift of
Miss Eva Gilchrist in memory of her uncle P. A. Daniel, 1956 3334-4. Photo: BAL.

from *Rosa mundi* (rose of the world), a phrase often used for the Virgin, and this Christian meaning would be appropriate as Rosamund is most often described as an innocent victim who suffers and is sacrificed for love.[47] The use of flower language for deciphering any painting is difficult and frankly problematic. Although a crescendo of books on the subject appeared in France and England from the eighteenth century on, flower language does not appear ever to have been used literally in society as a means of communicating.[48] Furthermore, the word *language* is misleading, as the personal variations or definitions can differ significantly from author to author and from artist to artist. Rather than being true dictionaries, these volumes were more like gift books (we might say coffee-table books today), meant for decoration and casual female amusement. There is no clear indication that Van Gogh was aware of or ever employed this kind of text. Scholars have explored instead the potential of emblem books, illustrated books of both secular and religious material developed in the fifteenth and sixteenth centuries, as likely source material for interpretations of his subjects.[49] Van Gogh rarely offered in his letters symbolic meanings for a specific flower—the sunflower is the best example of one for which he did [50]—but as with many artists and writers, his were frequently idiosyncratic.

Irises also appeared less as narrative clues and more as generalized indicators of spring and/or echoes of youth in British portraits/genre pictures of girls and young women from the Victorian era, examples of which include *The Nest* (figure 19) by John Everett Millais and *Spring* (figure 20) by Lawrence Alma-Tadema. William Holman Hunt's *May Morning on Magdalen Tower* (figure 21) celebrates a contemporary ceremony in which the choral ministers of Magdalen College greet the sun on the morning of the first of May. Although the ceremony had its origins in druidical ritual, we are reminded of Christian beliefs by the surrounding architecture as well as by the

19. John Everett Millais (English, 1829–1896), *The Nest*, 1887. Oil on canvas,
 45.7 × 60.9 cm (18 × 24 in.). Roy Miles Fine Paintings. Photo: BAL.

20. Lawrence Alma-Tadema (Dutch/English, 1836–1912), *Spring*, 1894. Oil on canvas, 178.4 × 80 cm (70¹/₂ × 31¹/₂ in.). Los Angeles, JPGM, 72.PA.3.

21. William Holman Hunt (English, 1827–1910), *May Morning on Magdalen Tower*, 1888–90. Oil on canvas, 157.5 × 204.5 cm (62 × 80½ in.). Liverpool, National Museums on Merseyside, Lady Lever Art Gallery, LL3599. Photo: BAL.

lilies and irises in the center foreground. The flowers conflate the pagan welcoming of spring with the worship of the Virgin Mary, to whom Magdalen College was dedicated.

So what of Van Gogh? Did he choose to paint irises simply because they were convenient? Fragrant? Or because they presented the right color combination? Was he attracted to a plant that could flourish even though neglected and isolated (like himself?) within a garden-asylum? Could irises and spring in Saint-Rémy signal a period of personal renewal of hope and health? Are we to understand them as a symbol of his own suffering or as a more generally redemptive spiritual image? He himself had told his brother Theo that art

was the result of a "great number of complicated combinations." Vincent was not unaware of the centuries of multivalent meanings associated with flowers. He had been raised in a religious environment that had used images and nature as teaching tools. He had been exposed to the revival of the "northern emblematic tradition, a verbal-pictorial art form dating back to the sixteenth and seventeenth centuries that finds the revelation of the infinite in the finite, God-given meaning in the book of nature."[51] He was a great admirer of Jules Michelet, whose own metaphoric style of writing compared women to flowers (for example) in order to more persuasively convey his meanings and used images from the history of art to make his writing an evocative, visual experience. Vincent "responded to the world—nature, people, pictures and books—through an associative network constantly enriched by accrued experience."[52] And while he had rejected organized religion, his belief in something divine and his commitment to the personal discovery of truth through the study of nature were deeply ingrained. Far from proposing a programmatic reading of symbolic meaning for *Irises*, we should rather bear in mind the breadth of his knowledge of cultural meanings and artistic images—these "complicated combinations"—and his own associative manner of thinking.

Van Gogh must have enjoyed irises; this was not the first time he had painted them, nor the last. In the previous year, he had painted a landscape (figure 22) that he described to his friend Émile Bernard as

a view of Arles. Of the town itself one sees only some red roofs and a tower, the rest is hidden by the green foliage of fig trees, far away in the background, and a narrow strip of blue sky above it. The town is surrounded by immense meadows all abloom with countless buttercups—a sea of yellow—in the foreground these meadows are divided by a ditch full of violet irises. (Vincent to Émile Bernard, Arles, second half of May 1888, B05)

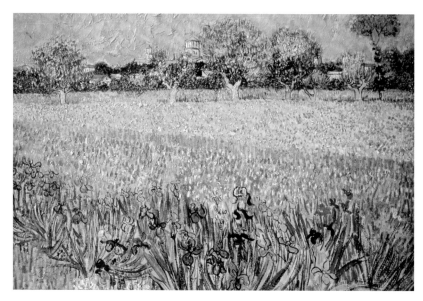

22. Vincent van Gogh, *View of Arles with Irises in the Foreground*, May 1888. Oil on canvas,
54 × 65 cm (21¼ × 25⁹/₁₆ in.). Amsterdam, Van Gogh Museum (F409). Photo: Snark /
AR, N.Y.

Although this work perhaps reminds us of field/city landscapes by
his fellow Dutch landscape painters of previous centuries, Vincent
described the same scene to Theo as "a beautiful Japanese dream."
"Japanese" here refers not just to his compositional decisions (the
high horizon, for example) but also to his idealized conceptions
of Japan and Provence and their equivalence in his mind as sun-
soaked, more primitive, natural, and therefore ideal locations for
the production of art.[53] Irises (though a different species) were also
esteemed and depicted by Japanese artists, and Vincent may have
associated irises with Japan, though he never said so in his letters.
It is worth noting that he painted irises only while in Provence;
because they grew there in profusion, fields of irises were generally
associated with the region, much as watery iris gardens were linked

to Japan. In *View of Arles with Irises in the Foreground*, the irises are part of a larger image; more drawn than painted, they are the entry point into the composition and a framing device—but are not themselves the subject.

Iris (figure 23), now in the National Gallery of Canada, takes a single iris plant as its central subject.[54] Vincent did not mention *Iris* in his letters, but stylistically it seems most closely aligned with four paintings usually dated to April 1889 and completed in Arles: *Garden with Butterflies* (figure 24), *Clumps of Grass* (figure 25), *A Field of Yellow Flowers* (figure 26), and *Butterflies and Flowers* (figure 27).[55] These five paintings feel like true nature studies, similar in their palette, rhythmic brushwork for rendering grass, horizonless compositions, and macroscopic, top-down viewpoint. *Iris*, however, is more ambitiously scaled than the others and feels "composed," with the single plant dominating the center and grass/brushwork radiating out like spokes on a wheel or the rays of the sun. Although large, *Iris* was painted on a *carton*,[56] an economical, lightweight, rigid pasteboard frequently used for painting outdoors due to its portability. Van Gogh used it a number of times while working in Paris—oddly enough, primarily for portraits—but rarely later on.[57] An unusual support for his oeuvre in Arles, it would nonetheless have been appropriate for a plein air study of flowers and grass.[58]

Assuming they were painted the same year,[59] *Iris* must have been painted earlier than the Getty *Irises*—in the former there is just one full bloom and multiple swelling buds, while *Irises* is filled with blooms, some of which are beginning to fade. Bearded irises bloom for about three weeks (slightly longer if the weather is cool; more briefly if it is hot), so we can guess that these two paintings were separated by about ten days or so. Given the timeframe—Vincent tells his brother in a letter written from two to seven days after his arrival that he had "two more on the go—violet irises and a lilac bush"[60]—and the

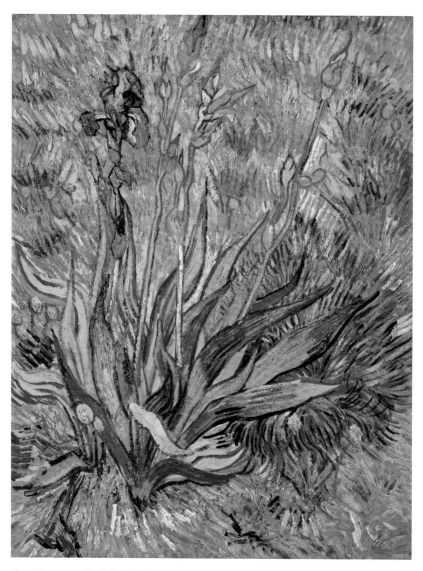

23. Vincent van Gogh, *Iris*, April/May 1889. Oil on board, 62.2 × 48.3 cm (24 1/2 × 19 in.).
Ottawa, National Gallery of Canada, 6294 (F601).

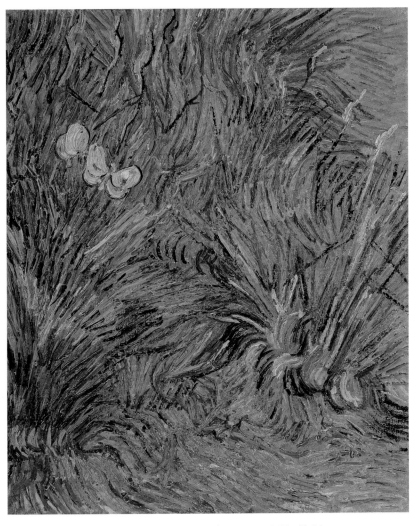

24. Vincent van Gogh, *Garden with Butterflies*, late April 1889 (?).Oil on canvas,
55 × 45.5 cm (21⅝ × 17⅞ in.). Amsterdam, Van Gogh Museum (F402). Photo:
Vincent van Gogh Foundation.

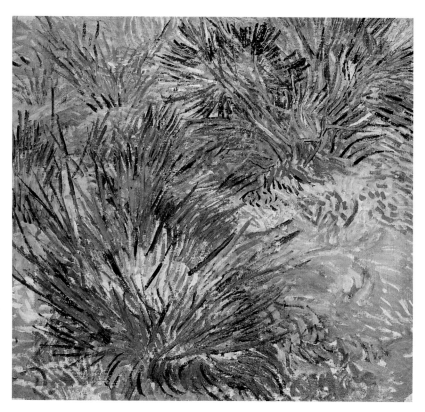

25. Vincent van Gogh, *Clumps of Grass*, April 1889. Oil on canvas, 45.1 × 48.8 cm
(17³/₄ × 19¹/₄ in.). Kanagawa, Japan, Pola Museum of Art (F582).

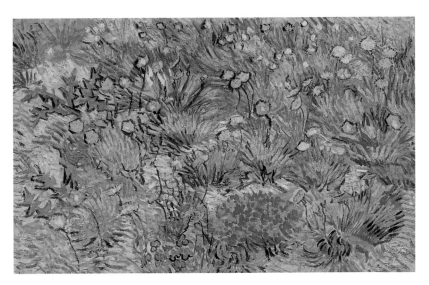

26. Vincent van Gogh, *A Field of Yellow Flowers*, late April 1889. Oil on canvas on pasteboard, 34.5 × 53 (13¼ × 20¾ in.). Winterthur, Switzerland, Kunstmuseum, Presented by Dr. Herbert and Charlotte Wolfer-de-Armas, 1973, 1534 (F584).

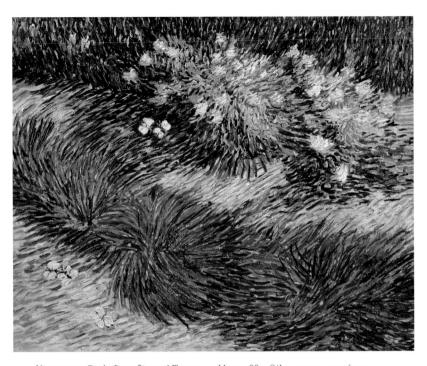

27. Vincent van Gogh, *Butterflies and Flowers*, ca. May 1, 1889. Oil on canvas, 51 × 61 cm (20⅛ × 24 in.). Private collection (F460).

similarity of *Iris's* palette to the other four nature studies, it seems plausible that the National Gallery of Canada's painting could have been one of the last things he did in Arles.[61] It might not have been, of course; he could easily have picked up again the approach he had been using in Arles immediately on arrival in Saint-Rémy and simply not mentioned to Theo the study on pasteboard. But the yellow-green color range differs somewhat from *Irises's* more blue-green foliage and employs what seems to be a "smorgasbord of leftover color."[62] It is not difficult to imagine that with *Iris* Vincent finished off some paint or a palette before leaving town. More importantly, the National Gallery's painting seems to be a kind of a pivot point between those fragmentary studies from above and the more formalized *Irises*, as if he were both finishing one idea and beginning something else. He even used similar blue reinforcing outlines in both pictures, though less consistently in *Iris*. For the earlier picture, the artist appears to have been seated at eye-level with the bloom, which is seen "straight-on." Yet when the ground is depicted, the angle of vision shifts. Horizon is eliminated and the grass tips up vertiginously, effectively turning into wallpaper behind the iris. The result is a strange push and pull of perspective, in which the viewer is given the sensation of looking down through space at the ground, while the massed grasses rebuff any real recession into the picture plane. In the Getty *Irises*, Vincent shifted his position to sit down on the ground in front of his subject, allowing him to crop the view more tightly, compress the space, and create a frieze-like composition. Looking at the context of his working experience in Saint-Rémy—from personal changes to artistic interests—we begin to see how he moved from one kind of figuration to the next, how he came to the simple decision to sit upon the ground.

It may well be that I shall stay here long enough—I have never been so peaceful as here and in the hospital in Arles—to be able to paint a little at last. (Vincent to Theo, Saint-Rémy, ca. May 10–15, 1889, 591)

The following May, a full year after painting *Irises*, Vincent returned to blooming irises, but this time he cut bunches of them to arrange more traditionally in vases. Having spent a year in the asylum, he was tired of the confinement and particularly, despite his painting, the lack of stimulation. On May 3, 1890, he wrote Theo that he was the only one who had work and lamented the "terrible idleness" of the other patients. Concerned that what remained of his "wits and of the power to work" were "absolutely in danger," he agitated for change and prepared to leave the asylum in order to live instead under the care of Dr. Gachet in Auvers in the north. A little more than a week later, though he was hoping to leave imminently (he left on May 16), he was still hard at work on three floral still lifes, including *Bouquet of Irises* and *Vase with Irises* (figures 28 and 29).

I am doing a canvas of roses with a light green background and two canvases representing big bunches of violet irises, one lot against a pink background in which the effect is soft and harmonious because of the combination of greens, pinks, violets. On the other hand, the other violet bunch (ranging from carmine to pure Prussian blue) stands out against a startling citron background, with other yellow tones in the vase and the stand on which it rests, so it is an effect of tremendously disparate complementaries, which strengthen each other by their juxtaposition. (Vincent to Theo, Saint-Remy, May 11 or 12, 1890, 633)

The return to irises as a subject seems somehow appropriate, like the closing of parentheses. On arrival at the asylum he had begun by painting living irises, rooted in the ground, but once he had

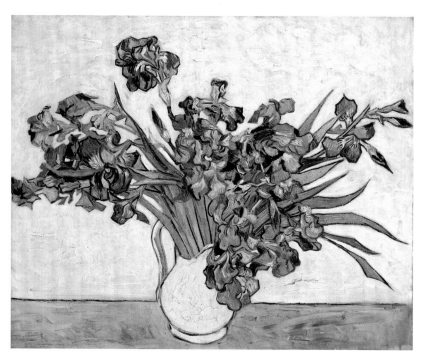

28. Vincent van Gogh, *Bouquet of Irises*, May 1890. Oil on canvas, 73.7 × 92.1 cm
(29 × 36¼ in.). New York, Metropolitan Museum of Art, Gift of Adele R. Levy,
1958 (58.187) (F680). Photo: AR, N.Y.

determined to leave, his irises were likewise severed from an environment that had become oppressive to him. Like their creator, the irises in vases feel constrained by, or rather strain to break free of, the container that holds them.

Irises also brought Van Gogh back to his interest in color arrangements (the pink background of the Metropolitan Museum of Art painting has faded) and effects; he even described them using the language of "complementary colors" he had employed in 1888 but had not used during his time in the asylum.[63] Like his *Sunflowers* from August 1888 (figure 30), these iris compositions are stripped down, with the backgrounds reduced to two zones of color. The voluptuous, writhing blooms create their own volume and space, with assists from the juxtaposition of color and the textural, directional brushwork that at times creates a halo effect around a bloom. But while his earlier *Sunflowers* were built up, even sculpted, out of thickly applied paint, these irises were painted somewhat more thinly, and bold, graphic outlines were employed to delineate form. The end result recalls Van Gogh's beloved Japanese woodblock prints, with their flat zones of color and outline. The superabundance of flowers crammed into and even spilling out of the vases may owe something to his Dutch predecessors—for example, Jan van Huysum's *Vase of Flowers* (figure 31) has a similar tower/pyramid of enthusiastic flowers on a minimal, monochrome background—but, unlike Van Huysum, Van Gogh cares nothing for directional lighting or the transparency and relative texture of dew, petals, and leaves. The startling thing about all of Van Gogh's iris paintings is that despite their stylization—we can never forget that we are looking at a Van Gogh painting—we also feel that, as Theo wrote, it is indeed "a thing you are simply confronted with." He was able to communicate the presence of a living thing, even in a still life.

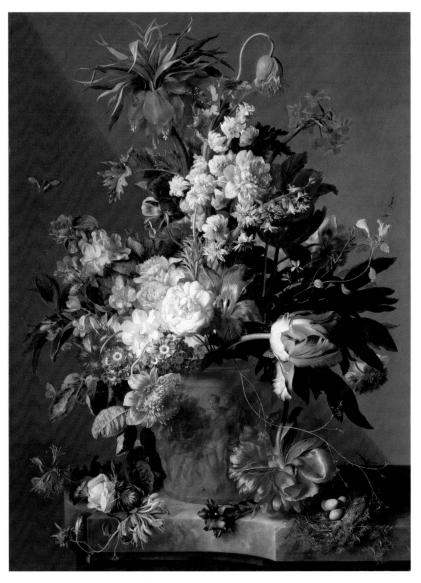

31. Jan van Huysum, *Vase of Flowers*, 1722. Oil on panel, 79.4 × 61 cm (31¼ × 24 in.). Los Angeles, JPGM, 82.PB.B.70.

Besides, you know that Gauguin liked them [pictures of sunflowers] extraordinarily. He said to me among other things, "That... it's... the flower." (Vincent to Theo, Arles, January 22/23, 1888, 573)

Gauguin was struck by Vincent's capacity to capture not just the image but the essence of the thing, its vitality, its singularity.

Van Gogh's ability to represent—to make present—nature also seems to have been what Theo admired most in Vincent's painting and particularly in the Getty *Irises*.

The exhibition of the Independents is over and I've got your irises back; it is one of your good things. It seems to me that you are stronger when you paint true things like that... The form is so well defined and the whole is full of colour. (Theo to Vincent, October 21, 1889, T19)

Theo chose *Irises* for the Salon des Indépendants exhibition and was pleased to report that it was well received and that people continued to talk about it. He preferred it to Vincent's now iconic *Starry Night* (see figure 76), expressing concern in the same letter that "the search for some style is prejudicial to the true sentiment of things." He also worried that Vincent's pursuit of things beyond the appearance of nature was potentially detrimental to his mental health.

In all of them there is a vigour in the colours which you have not achieved before—this in itself constitutes a rare quality—but you have gone further than that, and if there are some who try to find the symbolic by torturing the form, I find this in many of your canvases, namely in the expression of the epitome of your thoughts on nature and living creatures, which you feel to be so strongly inherent in them. But how your brain must have laboured, and how you have risked everything to the very limit, where vertigo is inevitable!

For this reason, my dear brother, when you tell me that you are working again, in which from one point of view I rejoice, for by this you avoid lapsing into the state of mind which many of the poor wretches who are taken care of in the establishment where you are staying succumb to, it worries me a little to think about it, for you ought not to venture into the mysterious regions which it seems one may skim cautiously but not penetrate with impunity before you recover completely. Don't take more trouble than necessary, for if you do nothing more than simply tell the story of what you see, there will be enough qualities in it to make your pictures last. Think of all the still lifes and the flowers which Delacroix painted when he went to the country to stay with Georges Sand. (Theo to Vincent, Paris, June 16, 1889, T10)

As brother and best friend, perhaps Theo was in the best position to know what Vincent was capable of or where danger might lay. But in addition to believing that some deeper, mysterious truth could be found in the study and depiction of nature, the brothers also agreed that the activity of painting was in fact essential to Vincent's well-being and happiness, especially while in the asylum. Theo's reference to Delacroix reminds Vincent not only of the painting of flowers by one of his artistic heroes but also of Delacroix's own successfully therapeutic painting of nature while in retreat.

And though here you continually hear terrible cries and howls like beasts in a menagerie, in spite of that people get to know each other very well and help each other when their attacks come on. (Vincent to Jo, Saint-Rémy, May 10–15, 1889, 591)

I assure you that I am quite all right here...the *fear* of madness is leaving me to a great extent, as I see at close quarters those who are affected by it in the same way as I may very easily be in the future...

I am forced to ask you again for some paints and especially for canvas. When I send you the four canvases of the garden I am working on, you will see that, considering my life is spent mostly in the garden, it is not so unhappy....

For though there are some who howl or rave continually, there is much real friendship here among them; they say we must put up with others so that others will put up with us, and other very sound arguments, which they really put into practice, too. And among ourselves we understand each other very well. (Vincent to Theo, Saint-Rémy, May 22, 1889, 592)

Despite fears about his sanity, despite incarceration in a place where fellow patients might "howl and rave," Vincent asserted that his life could not be that bad when he spent it painting in a garden. Throughout his life he repeatedly quoted, apparently without irony, "Everything is for the best in the best of worlds," a phrase used by Voltaire's Pangloss, who "had always suffered horribly; but having once maintained that everything was for the best, he still maintained it without believing it."[64] Van Gogh may have misunderstood Voltaire's irony—Pangloss is a buffoon—but apparently he preferred to take it as a statement of optimistic stoicism. Painting, particularly painting the glories of nature, was fundamental to Vincent's effort to make the best of it.

My dear sister, it is my belief that it is actually one's duty to paint the rich and magnificent aspects of nature. We are in need of gaiety and happiness, of hope and love.

The more ugly, old, vicious, ill, poor I get, the more I want to take my revenge by producing a brilliant colour, well arranged, resplendent. Jewellers too get old and ugly before they learn how to arrange precious stones well. And arranging the colours in a picture in order to make

them vibrate and to enhance their value by their contrasts is something
like arranging jewels properly or—designing costumes. You will see
that by making a habit of looking at Japanese pictures you will love to
make up bouquets and to do things with flowers all the more. (Vincent
to Wilhemina, Arles, September 9 and 16, 1888, w7)

Vincent viewed nature, art, and work as solace for the suffering in
life; for him color "well arranged," flowers (no doubt well arranged),
and Japanese pictures were all linked together to satisfy our need for
gaiety, happiness, hope, and love. He was not alone in this view. Léon
Daudet recorded an exchange between the art critic Octave Mirbeau
and the Impressionist painter and devoted gardener Claude Monet.
Mirbeau shared with Monet a love of horticulture (and, incidentally,
Japonisme) and was (perhaps not incidentally) an ardent collector of
irises, growing them in his garden at Carrières-sous-Poissy.[65] The
critic also was an admirer of Van Gogh's work and purchased *Irises*
from Van Gogh's paint/paintings dealer Père Tanguy in 1892. Monet,
upon being shown the painting, responded by saying, "How could a
man who has loved flowers and light and has rendered them so well,
how could he have managed to be so unhappy?"[66] This expression of
wonderment conveyed perhaps as much about Monet and his own
relationship with art and nature as about Van Gogh, but the two art-
ists' underlying motivation for painting flowers was similar: flowers
and light bring joy; a painting that is able to represent the beauty of
nature can and should communicate that joy. Further, a painter who
can successfully create an image that reflects the joy and light of
nature *should* be *made* happy by "the very act of its creation."[67] Monet's
own paintings of irises in his gardens at Giverny appear as oceans of
shimmering color and are a testament to the very individual results
to be had from this pursuit (figure 32).

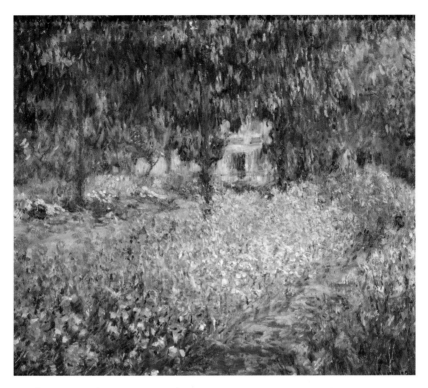

32. Claude Monet (French, 1840–1926), *The Artist's Garden at Giverny*, 1900. Oil on canvas. 81 × 92 cm (31⅞ × 36¼ in.). Paris, Musee d'Orsay. Photo: Hervé Lewandowski / Réunion des musées nationaux / AR, N.Y.

At the point I am now, however, I see a chance of giving a true impression of what I see. Not always literally exact or rather never exact, for one sees nature through one's own temperament. (Vincent to Theo, Nuenen, ca. April 11, 1885, 399)

For his part, Mirbeau also saw in Van Gogh's work a remarkable relationship with and ability to render nature. The year before he purchased *Irises*, he wrote a stirring review of a memorial retrospective showing of the artist's work at the Salon des Indépéndants.

Yet even in the upheaval of these fantastic flowers that rear up and tuft their feathers like demented birds, Van Gogh always maintains his wonderful qualities as a painter and a nobility that is moving, as well as a tragic grandeur that is terrifying... the goodness of life radiates from the earth in flutters of light and expands into the tender paleness of peaceful skies and their refreshing breezes. Oh, how he understood the exquisite soul of flowers: How delicate becomes the hand that had carried such fierce torches into the dark firmament when it comes to bind these fragrant and fragile bouquets! And what caresses has he not found to express their inexpressible freshness and infinite grace? (*L'Echo de Paris*, March 1891)[68]

Feeling the tragedy of Van Gogh's recent death, Mirbeau suggested the paradoxes within/between his work and life: "tragic grandeur," "goodness of life," "fierce," and "fragile." Like Theo, who felt Vincent was at his best when rendering things that were "true," the critic admired—and perhaps he was thinking of the "fantastic" *Irises* he would soon make his own—Van Gogh's ability to capture the essential nature of flowers and the movement of light, air, and plants. Mirbeau went on to praise "his eloquence and his prodigious ability to render life" as well as his "observation of nature" but asserted that

he could neither forget his personality nor contain it, whatever the spectacle or materialized dream before him... He was not, however, absorbed in nature; rather he had absorbed nature within himself; he forced it to become more supple, to mold itself to the forms of his thought, to follow him in his flights of fancy, to submit, even to his characteristic distortions. To a rare degree, Van Gogh possessed that which distinguishes one man from another: style.

The poet identified then what we see and feel now: in *Irises* Van Gogh created the illusion of a living thing in his own terms, mimesis without precise simulacrum. Vincent himself wrote about giving a "true impression of what I see" and referenced Zola's famous statement about seeing nature "through one's own temperament." Van Gogh found confirmation of his own path in Zola's art criticism, in which the writer decried art that followed the same old formulas, urged "free manifestations of human genius," and defined a work of art as "a corner of nature [*création*] as seen through a temperament." If we understand *temperament* (a wonderfully flexible, amorphous term) as something like "personal sensibility,"[69] then Van Gogh took the concept a step further, using it as an explanation and justification of style. Mirbeau similarly asserted that in seeing nature through his temperament, his personal artistic experience and uncontained personality, Van Gogh "forced it... to submit, even to his characteristic distortions." According to Mirbeau, style—as much as Van Gogh's ability to understand "the exquisite soul of flowers"—distinguished him from other artists. Mirbeau did something else that is interesting; he made a connection between Van Gogh's characteristic brushwork—made more personal in Mirbeau's word "caresses," which essentially eliminates the brush and puts the artist in physical (loving!) contact with the paint and the subject—and his expressive capabilities.

Van Gogh's temperament is so physically, visibly present in his touch, and his ability to convey life in paint is so persuasive, that something rather surprising happens: we begin to associate or even identify the artist not just with his mode of painting as an expression of his inner life, but with his choice of subject matter. (Vincent, who wrote his sister, "I, who read books to find the artist who wrote them," would not necessarily disagree.[70]) Shoes, sunflowers, olive groves, irises, starry nights, and wheat fields become stand-ins for Vincent, or some aspect of himself, and we are drawn, perhaps more so than for any other artist, to read his life on his canvases.

> It is true that at moments, when I am in a good mood, I think that what is alive in art, and eternally alive, is in the first place the painter and in the second place the picture. (Vincent to Wilhelmina, Arles, ca. August 27, 1888, w08)

Why irises? They were there and blooming, a compelling subject taken from nature, rich in color and associations. Time spent in the garden contemplating and painting this bed of irises was both solace and stimulation, fulfillment of a duty to work and to share the joy of nature, and escape from the horror of a troubled mind and the asylum.

> But never mind, I think I am not going to urge you too much to read books or dramas, seeing that I myself, after reading them for some time, feel obliged to go out and look at a blade of grass, the branch of a fir tree, an ear of wheat, in order to calm down. So if you want to do, as the artists do, go look at the red and white poppies with their bluish leaves, their buds soaring on gracefully bent stems. The hours of trouble and strife will know how to find us without our going to look for them. (Vincent to Wilhelmina, Saint-Rémy, July 2, 1889, w13)

CHAPTER 3

WITHIN AND BEYOND THE WALLS OF SAINT-PAUL-DE-MAUSOLE, SAINT-RÉMY-DE-PROVENCE

Quite near here there are some little mountains, grey and blue, and at their foot some very, very green cornfields and pines. (Vincent to Jo, ca. May 10–15, 1889, Saint-Rémy, 591)

In order to arrive in Saint-Rémy, Van Gogh traveled north from Arles past, and then along the northern frontage of, the Alpilles—the "little Alps," a rugged range of mountainous-looking limestone hills. Although the town was just fifteen miles from Arles, it seemed like another world. Arles, located between two branches of the Rhône River in the Camargue delta, was dominated by flat, fertile fields of wheat, poppies, lavender, and sunflowers.[71] In contrast, Saint-Rémy had more arid, rocky soil, encouraging the cultivation of olive orchards (figure 33), cypresses, and wild thyme, in addition to corn and wheat. The asylum, in the former monastery of Saint-Paul-de-Mausole, is located on what are still the southern outskirts of town, near the foot of the Alpilles and the ancient Roman ruins of Glanum (figure 34). From his east-facing bedroom window there,[72] Vincent was able to look out across (and eventually paint) an enclosed field behind the asylum with the foothills of the mountainous landscape in the distance to his right.

33. Vincent van Gogh, *The Olive Trees*, June 1889. Oil on canvas, 72.6 × 91.4 cm (28⅝ × 36 in.). New York, Museum of Modern Art, Mrs. John Hay Whitney Bequest. Photo: Scala / AR, N.Y.

Van Gogh had read of the Alpilles and the region in *Tartarin on the Alps* by the Provençal writer Alphonse Daudet[73]—"That chain of little hills perfumed with thyme and lavender; neither very difficult nor very high (some 450 to 600 feet in elevation above the level of the sea), which form a horizon of blue waves to the Provençal roads"[74]—and he had seen them in his forays from Arles out to Le Crau and Tarascon. But being up close to their northern face introduced him to a terrain that, in comparison to Arles, was as yet unchanged by new agricultural techniques. The landscape of Saint-Rémy represented an older, more traditional Provence—a Provence that cul-

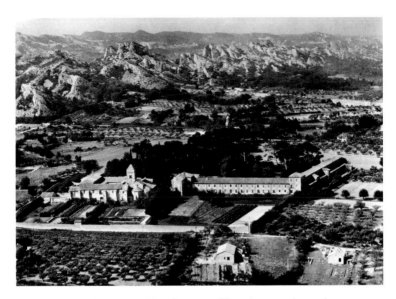

34. Aerial view of St.-Paul-de-Mausole, postcard from the 1940s. Amsterdam, Van Gogh Museum. Photo: Vincent van Gogh Foundation.

tural revivalists of the Félibrige movement like Daudet and the poet Frédéric Mistral (1830–1914) were striving to celebrate and preserve.[75] The Félibrists were one of many regionalist associations in nineteenth-century France that were resisting the loss of provincial cultural identity, especially its languages and literature, to centralized nationalism. Publications of poetry and novels in French and Occitan (the local language), as well as festivals of regional costume and dance, were effective in the popular dissemination both of Provençal traditions and an image of the Midi.

With his conception of the region colored by his reading of French naturalist and Félibrist novelists, Vincent viewed his paintings of Arles and Saint-Rémy as a totality, as "impressions of

Provence." The subject matter he selected in Saint-Rémy reflected this effort to obtain "expert knowledge with regard to the Provençal south" by painting "the olives, the fig trees, the vines, the cypresses, all the other characteristic things, the same as the Alps."[76] In this group of Provençal impressions, Van Gogh employed a somewhat altered palette for Saint-Rémy; where the images of Arles were dominated by the yellows of wheat fields and sunflowers, the olive groves, mountains, and irises of Saint-Rémy required more blues and greens. Irises, like olive trees and cypresses, have a particular association with Provence; they, too, are tough plants, able to withstand the climate and survive with minimal care. Also like olive trees and cypresses, irises carried historic cultural and religious meanings; irises and cypresses were both traditionally planted in cemeteries, and olives and irises have a place in Christian iconography. Vojtěch Jirat-Wasiutyński has argued for a development within Vincent's work in Saint-Rémy, which shifts "from early images of spiritual consolation to his subsequent retreat from overt symbolism, from celebrations of a classic Provence to images anticipating his return north."[77] Rooted as its subject is in the very soil of the region, *Irises* does seem to belong to the "celebrations of a classic Provence," particularly when we remember that he painted irises only while in the south. Perhaps the irises in vases (see figures 28 and 29), painted a year later as he was packing to leave the asylum, with their arrangements bound to the tradition of Dutch flower painting, offer a farewell to the south and look to "his return north." The concept of *Irises* as an image of spiritual consolation, however, requires more careful consideration.

> Since I have been here, the deserted garden, planted with large pines beneath which the grass grows tall and unkempt and mixed with various weeds, has sufficed for my work, and I have not yet gone outside. (Vincent to Theo, Saint-Rémy, May 22, 1889, 592)[78]

35. Floor plan of the Saint-Paul-de-Mausole asylum, ca. 1866:
 A. Men's quarters
 1. Van Gogh's room
 2. The wing where Van Gogh's studio was located
 B. The wheat field inside the walls (at this date a garden)
 C. The place where Van Gogh painted *The Garden of the Asylum at Saint-Rémy*
 (see figure 39). Reproduced in *The Paintings of Vincent van Gogh in the Collection
 of the Kröller-Müller Museum* (Otterloo, The Netherlands, 2003), p. 285.

Vincent assured both Theo and his sister that, having arrived at the
asylum, he was finding solace painting in the walled garden. The
large, neglected park was constructed in three terraces and framed
on its north and eastern sides by the wings of the men's quarters of
the larger complex of Saint-Paul-de-Mausole (figure 35); to the west,
over the wall, was the main road leading south to Glanum or north
into town, and beyond the southern wall in the distance were the
Alpilles. The asylum's well-preserved Romanesque architecture—the

cloister and tower date to the twelfth and thirteenth centuries—was beginning to be admired during the later nineteenth century. In 1873, architect Henri Revoil[79] published his scholarly three-volume work *L'Architecture Romane du Midi de la France*, which presented line drawings of elevations and architectural details of the cloister of Saint-Paul-de-Mausole as well as of other Romanesque monuments in southern France. The governmental Commission des Monuments Historiques, established in 1837 in response to a new conception of the country's architectural patrimony as well as a growing appreciation of medieval art, sought to protect, preserve, and restore France's architectural heritage. In 1883, the commission gave protected status to the cloister of Saint-Paul-de-Mausole. The commission's preservationist mission also included an ambitious effort to photograph the monuments.[80] Séraphin-Médéric Mieusement, who had proposed the creation of an enormous album of France's civil and religious monuments to the Ministry of Public Education as early as 1872 and later became official photographer for the Commission des Monuments Historiques, photographed Saint-Paul-de-Mausole some time before 1893 (figure 36). He was not alone: Jean-Eugene Durand, deputy chief administrator of the commission visited with his camera in 1891 (figure 37); the architectural historian Camille Enlart (1862–1927) and archeologist Philippe des Forts (1865–1940) also captured Saint-Paul on film. These photographers tended to focus primarily on the protected cloister and bell tower, as well as capitals and other sculptural details.

Interestingly, Van Gogh chose not to paint the admired cloister, though we might imagine something like his depiction of the courtyard at the hospital in Arles from the previous month (figure 38). Instead he headed out into the larger walled park. In *The Garden of the Asylum at Saint-Rémy* (figure 39), painted close on the heels of *Irises* and *Lilacs*, he gives us a glimpse of the exterior of the living quarters,

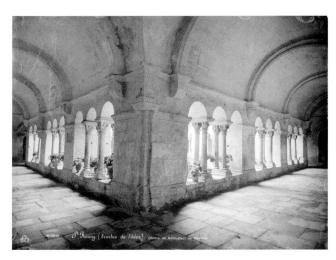

36. Séraphin-Médéric Mieusement (French, 1840–1905), *Cloister of Saint-Paul-de-Mausole in Saint-Rémy-de-Provence*, before 1893. Print from a silver gelatin-bromide glass negative. Paris, Médiathèque de l'Architecture du Patrimoine (Croisilles), MH0003840. Photo: RMN / AR, N.Y.

37. Jean-Eugene Durand (French, 1845–1926), *Cloister of the Priory of Saint-Paul-de-Mausole in Saint-Rémy-de-Provence*, 1891. Print from a silver gelatin-bromide glass negative. Paris, Médiathèque de l'Architecture du Patrimoine (Croisilles), MH0009253. Photo: RMN / AR, N.Y.

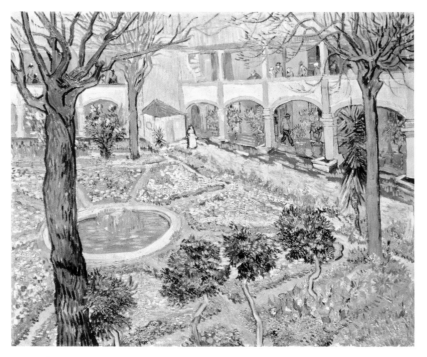

38. Vincent van Gogh, *Courtyard of the Hospital at Arles*, April 1889. Oil on canvas,
 73 × 92 cm (28¾ × 36¼ in.). Winterthur, Switzerland, Oskar Reinhart Collection
 'Am Römerholz' (F519). Photo: BAL.

with their eighteenth-century facades,[81] which faced the garden in
which he worked. But any indication of the character or style of the
buildings has been minimized; stone pilasters seen obliquely at the
left and a splash of yellow wall at the back mark the limits of the pic-
ture—and of Van Gogh's movements. The scene and the buildings
are dominated, even overwhelmed, by the lush, blooming bushes.
In September, while still recovering from an attack in mid-July (and
further bouts in August) and once again confined to the grounds,
Vincent created three views of the interior of a ward of the asylum—

39. Vincent van Gogh, *The Garden of the Asylum at Saint-Rémy*, early May 1889. Oil on canvas, 95 × 75.5 cm (37⁷⁄₁₆ × 29³⁄₄ in.). Otterlo, The Netherlands, Kröller-Müller Museum (F734).

a corridor (figure 40), a doorway to the garden, both of which are probably located on the ground floor of the north wing in which his studio is thought to have been, and the window in his studio.[82] *Pine Tree near the Entrance to the North Wing* also dates from the fall of 1889 and looks back at the doorway, which he had drawn from the inside looking out.[83] Finally in October, he ventured a view of the entire monastery from across a field (figure 41). But on his arrival that spring, the architectural nature of his new environment remained absent.

> The director mentioned that he had had a letter from you and had written to you; he tells me nothing and I ask him nothing, which is the simplest. (Vincent to Theo, Saint-Rémy, ca. June 2, 1889, 593)

> It is queer that every time I try to reason with myself to get a clear idea of things, why I came here and that after all it is only an accident like any other, a terrible dismay and horror seizes me and prevents me from thinking. (Vincent to Theo, Saint-Rémy, ca. June 9, 1889, 594)

> When I realize that here [in the asylum] the attacks tend to take an absurd religious turn, I should almost venture to think that this even *necessitates* a return to the North. Don't talk too much about this to the doctor when you see him—but I do not know if this is not caused by living in these old cloisters so many months, both in the Arles hospital and here. In fact, I really must not live in such an atmosphere, one would be better in the street. I am not indifferent, and even when suffering, sometimes religious thoughts bring me great consolation. (Vincent to Theo, Saint-Rémy, September 7 or 8, 1889, 605)[84]

Although he appears to have attempted at first to ignore it, Van Gogh was painting within the confines of a walled garden and living within what had been a medieval monastery. Saint-Paul-de-Mausole had

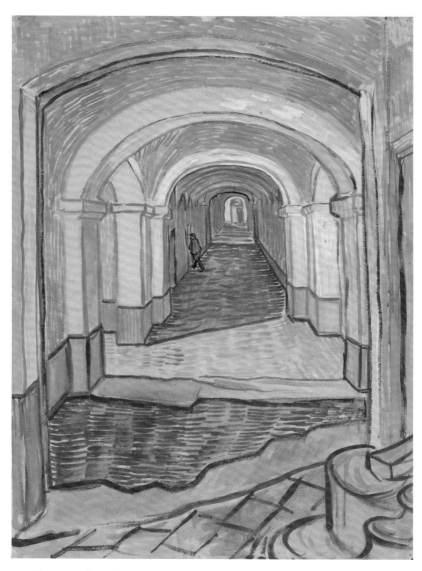

40. Vincent van Gogh, *Corridor in the Asylum*, September 1889. Brush and oils, black chalk on pin-laid paper, 61.7 × 47.4 cm (24¼ × 18⅝ in.). New York, Metropolitan Museum of Art, Bequest of Abby Aldrich Rockefeller, 1948 (48.190.2) (F1529). Photo: AR, N.Y.

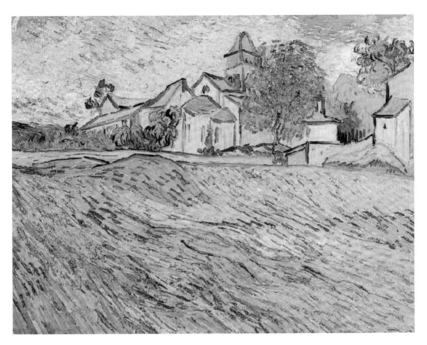

41. Vincent van Gogh, *View of the Church of Saint-Paul-de-Mausole*, October 1889. Oil on canvas, 44.5 × 60 cm (17½ × 23⅝ in.). Los Angeles, Collection of Elizabeth Taylor (F803). Photo: courtesy of Sotheby's.

long been a place that offered assistance to the sick, the poor, and the traveler or pilgrim.[85] In 1605, it was charged specifically with the care of the mentally ill under the direction of the Franciscan order. Having survived the desecrations of religious institutions during the French Revolution—in good part because of its societal services—Saint-Paul was purchased in 1807 by a Dr. Mercurin. With the assistance of male attendants/guards[86] and a female religious order,[87] the sisters of Saint-Vincent-de-Paul (and subsequently the sisters of Saint-Joseph d'Aubenas), Dr. Mercurin and his successors provided housing and basic treatment for the insane. The medical staff offered hydrotherapy (Vincent mentions spending two hours, twice a week,

in the bath), retreat from the world, and observation; the sisters were involved in patients' daily care and, according to Vincent, encouraged faith in (their construct of) Christianity.[88]

Four months into his stay, Vincent wrote Theo on two occasions, articulating his concern about the impact that the architecture had upon him and suggesting that living in "these sour old cloisters" was imparting a superstitious, religious aspect to his attacks. In his second letter, he reiterated his sensitivity to the architecture and its associative meanings, contrasting the religious architecture and the "superstitious" thoughts it stimulated with his "modern" interests in literature and art.

> And I insist on repeating it—I am astonished that with the modern ideas that I have, and being so ardent an admirer of Zola and de Goncourt and caring for things of art as I do, that I have attacks such as a superstitious man might have and that I get perverted and frightful ideas about religion such as never came into my head in the North.
>
> On the supposition that I am very sensitive to surroundings, the already prolonged stay in these old cloisters such as the Arles hospital and the house here would be enough in itself to explain these attacks. (Vincent to Theo, Saint-Rémy, September 19, 1889, 607)

He was not always—and may not have been able to be—specific about the nature of his psychological attacks, though they apparently included hallucinations, voices in his head, and paranoia.[89] He did not tell Theo exactly what "frightful" ideas he had but paradoxically acknowledged that religious thoughts could actually give him "great consolation." In the same letter, he disparaged the sisters working in the asylum, who encouraged its inmates to believe in the Virgin of Lourdes,[90] and was suspicious and critical of the asylum's administration, which seemed "too willing to cultivate these unhealthy religious

aberrations when it should be concerned with curing them."[91] The care of the ill by religious women was not an unusual practice (figure 42); the first half of the nineteenth century saw a proliferation of "highly organized, action-oriented female orders,"[92] which were involved not just in the care of the ill, the insane, and the poor but also in the education of children. While there was debate about the appropriateness of *les Bonnes Soeurs*' role and influence,[93] the care they offered

42. *Bonnes Soeurs, VII. Aupres du malade (Good Sisters, VII. Alongside the Sick)*, before 1907. French, staged historical photograph, "G.L." inscribed within a sunburst. Black and white postcard, 8.89 × 13.65 cm (3½ × 5⅜ in.). Chicago, DePaul University Libraries, Archives and Special Collections, Vincentian Postcard Collection, CM1-1572.

was frequently seen by the medical profession as being more patient and humane than that given by the standard ill-paid caregiver. Furthermore, economic practicality often overrode any objections, as the state simply could not afford to replace the services provided in institutions staffed by religious orders. Between the presence of the sisters and their proselytizing and the medieval walls that encompassed him, Vincent would have been constantly reminded of, and (as he later admitted) influenced by, a style of religiosity he repudiated.

We might be tempted here to recall the emblematic role that irises had played in the Marian cult and its appearance in Christian (Catholic) art. The sisters' encouragement of belief in the Virgin of Lourdes attests to the widespread revival of Marian worship in France in this period. The most obvious objection to the applicability of Marianism to a consideration of *Irises* is that Van Gogh was not Catholic; he had been raised as a Calvinist[94] and therefore would not have been inclined to make the association between a plant in a garden and one of the Catholic church's most traditional emblems. However, while Vincent was the son of a Protestant minister, his family had lived in a region that was predominantly Catholic, and he could hardly have avoided some exposure to the church and its imagery earlier in his life. Medieval art and architecture were not precisely anathema to him, but they made him somewhat uncomfortable; he admired a Gothic portico in Arles but felt alienated by it.

There is a Gothic portico here, which I am beginning to think admirable, the porch of Saint Trophime. But it is so cruel, so monstrous, like a Chinese nightmare, that even this beautiful monument of so grand a style seems to me of another world, and I am as glad not to belong to it as to that glorious world of the Roman Nero. (Vincent to Theo, Arles, March 18, 1888, 470)

He had painted and drawn other medieval religious structures, although they were in ruins—the old church tower at Nuenen in 1884, the abbey of Montmajour in 1888.[95] In August 1888, he compared positively the "effects" of the arrangement of colors in his paintings of sunflowers to that of "stained-glass windows in a Gothic church."[96] The following January, he wrote of his plan to hang *La Berceuse* (a portrait of his friend Mme Roulin) with two *Sunflowers* flanking it "like torches or candelabras."[97] When he described this plan again in a letter written on May 22 (shortly after painting *Irises*) from Saint-Rémy, he compared the arrangement to a triptych, a format common to medieval altarpieces, and imagined it providing comfort to someone such as a sailor at sea.[98] Certainly this verbal and visual language owed something to Vincent's exchanges with Émile Bernard and Paul Gauguin, both of whom reexplored more traditional religious subject matter in their pursuit of Symbolist art. But though he knew the work of and even admired artists like Jan Van Eyck (ca. 1395–ca. 1441), he insisted he did not look to their art for its spiritual content.

> The rest makes me smile a little—the rest of religious painting—from the religious point of view—not from the point of view of painting. And the Italian primitives (Botticelli, say), the Flemish, German primitives (V. Eyck, & Cranach)... They're pagans, and only interest me for the same reason as the Greeks do, and Velásquez, and so many other naturalists. (Vincent to Émile Bernard, Arles, June 26, 1888, B08)

Since in his letters he equated church architecture with the superstitious religious ideas he despised, we could consider his elimination of any indication of his surroundings and his myopic focus on a small corner of nature in *Irises* as a complete rejection/avoidance of religion and an embracement of nature. Such a polarization, however, is inappropriate; the discussion of religious painting cited above

appears in the same letter as his expression of admiration for Delacroix, Rembrandt, and Millet.

> Only Delacroix and Rembrandt have painted the face of Christ in such a way that I can feel him...and then Millet painted...the teachings of Christ.

Van Gogh did not reject spiritual feeling or even necessarily the teachings of Christ, but he did perceive organized religion as irrelevant and its traditional imagery as bankrupt in the face of modern life.[99]

In his letters to Bernard later that year, Van Gogh sternly argued against the biblical scenes that Bernard had been producing. He called Bernard's *Christ in the Garden of Olives* (1889; lost) a "nightmare" and denigrated the composition as a "cliché."

> I am speaking to you of these two canvases, and especially the first, to remind you that in order to give an impression of anxiety, you can try to do it without heading straight for the historical garden of Gethsemane; in order to offer a consoling and gentle subject it is not necessary to depict figures from the Sermon on the Mount—ah it is—no doubt—wise, right, to be moved by the Bible, but modern reality has such a hold over us that even when trying abstractly to reconstruct ancient times in our thoughts—just at that very moment the petty events of our lives tear us away from these meditations and our own adventures throw us forcibly into personal sensations: joy, boredom, suffering, anger or smiling. (Vincent to Émile Bernard, Saint-Rémy, ca. November 20, 1889, B22)

Although he wrote to Bernard in November, these are issues he had been working through for at least a year. He recalled toying with what he deemed "abstraction"—by which he meant subject matter that the

artist could never have seen, such as Gauguin's own *Agony in the Garden* (figure 43)[100]—while working with Gauguin in Arles in the fall of 1888 but felt this avenue led to a "brick wall."

Van Gogh instead sought to create a spiritual, "consoling" art, taken from direct contact with and observation of nature.[101] He believed that any of the powerful emotions captured in biblical texts and images that were still relevant to man could be evoked from the depiction of "modern reality," without explicit portrayal of biblical narrative.[102] His proposal of using an old religious format (the triptych with *La Berceuse*) with new content in order to elicit comparable, yet modern, and thus more relevant results suggests a willingness to

43. Paul Gauguin (French, 1848–1903), *The Agony in the Garden*, 1889. Oil on canvas, 73 × 92 cm (28¾ × 36¼ in.). West Palm Beach, Florida, Norton Museum of Art. Photo: BAL.

hybridize in order to achieve his ends. As late as 1888 he began painting (twice) a Christ in the Garden of Olives, only to scrape it off.

> For a second time I have scraped off a study of Christ with the angel in the Garden of Olives. You see, I can see real olives here, but I cannot or rather will not paint any more without models. (Vincent to Theo, Arles, ca. September 22, 1888, 540)

His numerous paintings of olive groves with their twisting, tortuous limbs, observed from life, also carry with them the subsumed memory of Christ's spiritual struggle (see figure 33); the tenacity of trees surviving in that harsh landscape are rich reminders of the long history of the Mediterranean landscape and of the determination and suffering of Christ, whose absence at once universalizes, modernizes, and personalizes the theme.

Van Gogh's efforts were comparable in a way to the work of writer Ernest Renan (1823–1892), a historian and philosopher whose highly controversial and influential *Life of Jesus* (1863) was one of the first texts to treat Jesus as a charismatic, "incomparable Man" rather than as a resurrected deity. For readers like Van Gogh, caught between a commitment to the principles of modernity and a need (whether nostalgic or otherwise) for some religious feeling or higher ideal, Renan's work offered an alternative that fell between the poles of a strictly materialist worldview and Christian orthodoxy—a way in which to respect the history of Christianity, even to call oneself a "Christian," but also to embrace science and to live a "modern" life.[103] In addition, Renan in his own writings depended on the visual imagery of the Mediterranean landscape, at once seemingly concretely observed and metaphorically evocative, to create his history—an approach that appealed to Van Gogh. Not long before going to Saint-Rémy, Vincent recalled Renan's writings in a letter to his sister.

I haven't reread the excellent books by Renan, but how often I think of them here, where we have olive trees and other characteristic plants, and the blue sky...Oh, how right Renan is, and how beautiful that work of his, in which he speaks to us in a French that nobody else speaks. A French that contains, *in the sound of the words*, the blue sky, the soft rustling of the olive trees, and finally a thousand *true and explanatory* things which give his History the character of a Resurrection. (Vincent to Wilhelmina, Arles, April 30, 1889, w11)

Through Renan's imagery of the Mediterranean landscape, Van Gogh connected the things he saw all around him and the images in his paintings with biblical concepts. Vincent answered his Symbolist friends with his own paintings based upon the observable, inspiring things of the earth, things that also had a long, complex history of meaning—fields of wheat, olive groves, laboring men, blooming flowers, starry skies. He deeply admired Christ's agrarian parables, about which he exclaimed, "What a sower, what a harvest, what a fig tree, etc." (Vincent to Émile Bernard, Arles, June 26, 1888, b08)—and perhaps many of his compositions should be viewed as a modernizing, painterly response to such parables.

This new art for modern man was by no means a slavish reproduction of nature. Van Gogh's interest in French naturalist literature affirmed what he believed: that the artist—art—offered some greater, "purer" truth or hope. He found affirmation in the introduction to Guy de Maupassant's *Pierre et Jean* (1888), in which Maupassant writes: "The realist, if he is an artist, will not try to show us a banal photograph of life, but to provide us with a vision that is at once more complete, more startling, and more convincing than reality itself."[104] In enthusiastic response, Vincent wrote to Theo, "Have you read the preface, where he explains the artist's liberty to exaggerate, to create in his novel a world more beautiful, more simple, more consol-

ing than ours."[105] Both Maupassant and Van Gogh argue for a personal and transformative encounter with nature and reality. These seemingly objective truths may be the artist's subject, but his emotions, memory, and experience will provide a more penetrating, enlightening view of the world.

Surely those first few weeks in the garden of the asylum were a period of great suffering, though he made every effort to think positively of his new situation—or not think of it at all. If we consider the iris not as a symbol of Christ or the Virgin but rather as an abstracted representation of transcendent suffering, the painting, with its bristling leaves, brilliant flowers, and urgent brushwork, takes on a mood similar to his letters of the period, swinging from fear and avoidance to a determination to live, to be happy, to "produce, even in the asylum."[106]

> It is just in learning to suffer without complaint, in learning to look on pain without repugnance, that you risk vertigo, and yet it is possible, yet you may even catch a glimpse of a vague likelihood that on the other side of life we shall see good reason for the existence of pain, which seen from here sometimes fills the whole horizon that it takes on the proportions of a hopeless deluge. We know very little about this, about its proportions, and it is better to look at a wheat field, even in the form of a picture. (Vincent to Theo, Saint-Rémy, June 1889, 597)

Perhaps it was better to look upon fields rather than pain, upon flowers rather than fear, upon painting rather than hopelessness, and upon the garden rather than the walls.

Like the iris, an enclosed garden was a common trope in medieval Christian imagery. Paintings and poetry placed the seated Virgin in a *hortus conclusus*, a walled garden, in which she is immaculate, sacred, and protected (figure 44). Walled gardens also represented

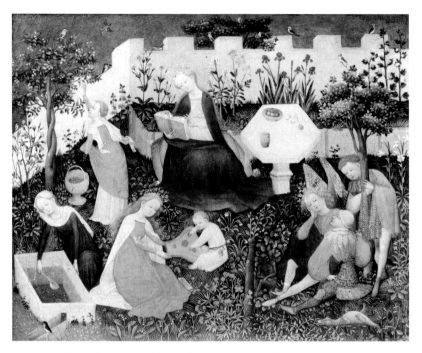

44. Upper Rhine Master (German), *The Little Garden of Paradise*, ca. 1410/20.
Tempera and oil on wood, 26.3 × 33.4 cm (10⅜ × 13⅛ in.). Frankfurt am Main,
Städelsches Museum, on permanent loan from the Historisches Museum.
Photo: Marburg / AR, N.Y.

paradise or the Garden of Eden, while scenes of courtly love took
place within the protected, cultivated space of a walled garden. Sabine
Schulze has recently observed that

> the wall is an important element. It isolates the garden as a place of
> retreat from an existence governed by outside influences. In all civi-
> lized societies, the garden represents an alternative to the rigors and
> the chaos of everyday life, a promise of happiness, a refuge within
> which the individual is free to live in accordance with God's original
> plan. We must regain this magical setting from nature through labor

and with imagination, reflection and respect. The knowledge of our loss remains, but the pain is soothed in the garden.[107]

The walled garden offered an almost primordial promise of happiness and refuge. But we must be judicious in applying the metaphor to the asylum garden. Van Gogh chose, after all, not to paint the cloister, in which walls would be a dominant feature; in his neglected park, walls are seen only in glimpses, through bushes and behind trees. His refuge was the garden, nature itself, rather than the walls that held them both in.

Van Gogh was certainly looking for retreat, for peace from the world outside and from turmoil within himself. But the irony of retreating to a monastery could not have been lost on him. For some time, Vincent had described artists as monks. In a letter, he encouraged his friend Émile Bernard to live "like a monk" in order to devote himself to painting.

> Better try to make your constitution as tough as old boots, a constitution to make old bones—better live like a monk who goes to the brothel once a fortnight—I do that, it's not very poetical—but I feel that my duty is to subordinate my life to painting. (Vincent to Bernard, Arles, June 26, 1888, B08)

To be an artist-monk required renunciation (within reason) and a feeling that one had a duty to produce for mankind. The monkish ideal was not just about self-abnegation but also required communal, cooperative living. In conceiving of his "Studio of the South," Van Gogh stressed that it would require commitment "body and soul" and even referred to Gauguin as the "abbot" who would "keep order."[108] Of course "order" was not achieved, in part because the two artists had some fundamental disagreements on the aims of art. Perhaps a few

flags should have been raised when they exchanged portraits earlier in 1888. Gauguin portrayed himself as the rebellious renegade Jean Valjean of Victor Hugo's *Les Misérables*, who lived independently, outside the law and society; Vincent painted a portrait of himself as a Japanese *bonze*—an archaic term for a Buddhist monk (figure 45). He borrowed his descriptors of a Buddhist monk—shaved head, eyes "slightly slanting"[109]—from the popular (though not particularly accurate) novel *Madame Chrysanthème* by Pierre Loti and combined them with his own features.[110] A green background painted in a ridged circular pattern around his head like a halo completed the holy man effect. The conceit was a means of communicating to Gauguin his ideal of the artist.

> If I might be allowed to stress my own personality in a portrait, I had done so in trying to convey in my portrait not only myself but an impressionist in general, had conceived it as the portrait of a bonze, a simple worshiper of the eternal Buddha. (Vincent to Theo, Arles, October 7, 1888, 545)

Vincent wanted to be both an "impressionist" (i.e., a member of the Parisian avant-garde) and a holy man, seeking a higher level of living and understanding.

> So come, isn't what we are taught by these simple Japanese, who live in nature as if they themselves were flowers, almost a true religion? And one cannot study Japanese art, it seems to me, without becoming merrier and happier, and we should turn back to nature in spite of our education and our work in a conventional world. (Vincent to Theo, Arles, September 24, 1888, 542)

45. Vincent van Gogh, *Self-Portrait Dedicated to Paul Gauguin (Bonze)*, 1888. Oil on canvas,
 61 × 50 cm (24 × 19¹¹/₁₆ in.). Cambridge, Mass., Harvard University, Fogg Art
 Museum (F476). Photo: AR, N.Y.

The Japanese artist, for Van Gogh, was characterized by a simple spirituality derived in part from being closer to nature. Vincent's aim was the pursuit of happiness, art, and truth through direct engagement with nature, shedding the impediments of modern life and the "conventional world." Although he protested the uselessness of religion for contemporary man and art, he, like others of his time, had a nostalgia for a more primitive, "natural" man.

> This country seems to me as beautiful as Japan as far as the limpidity of the atmosphere and gay colour effects are concerned. (Vincent to Émile Bernard, Arles, March 18, 1888, B02)

For Van Gogh going to Provence was like going to Japan; he charmingly wrote Gauguin that on his train ride down to Arles he "peered out to see whether it was like Japan yet."[111] The comparison may seem illogical to us today, but for Vincent the country and the region had a commensurate "otherness" that was rooted in both culture and climate. He believed both places were less urban, agrarian-based, more primitive societies, which enjoyed more sun, stronger colors, and a clearer sky. As we have seen, the Provence he looked for was the one which the Félibrists and naturalists described in their literature—a land worked in a traditional way by successive generations, people who lived in a simple, symbiotic relationship with the earth. This was also how he imagined the Japanese lived, and he expected to look out on a world as sharply delineated and colorful as the one found in Japanese woodblock prints. Even more, he hoped that "looking at nature under a bright sky might give me a better idea of the Japanese way of thinking and feeling," that experiencing the landscape and society of the south would bring him closer to his ideal of the Japanese artist/bonze.

Van Gogh's conception of Japan and Japanese art and artists fits into his broader utopian ideal of the artist and his role in society. The notion of the artist as a holy man, as more spiritually sensitive, self-sacrificing, with a higher duty to mankind and the power to create, seems at its apex when he wrote in rapid shorthand to Bernard describing Christ as an artist.

Christ alone, of all the philosophers, magicians, etc., declared eternal life—the endlessness of time, the nonexistence of death—to be the principal certainty. The necessity and the raison d'être of serenity and devotion.

Lived serenely *as an artist greater than all artists—disdaining marble and clay and paint—working in* LIVING FLESH. ie.—this extraordinary artist—Christ—hardly conceivable with the obtuse instrument of our nervous and stupefied, modern brains, made neither statues nor paintings nor even books...he states it loud and clear...he made...LIVING men, immortals...

These reflections, my dear old Bernard—take us a very long way—a very long way—*raising us above art itself.* They enable us to glimpse—the art of making life, the art of being immortal—alive. (Vincent to Émile Bernard, Arles, June 26, 1888, B08)

Van Gogh was not, of course, the only person to describe Christ as an artist. Gauguin (who applied his features to images of Christ) and others made comparisons between Christ's suffering for man and the contemporary artist's struggles (financial, social, spiritual) in his/her efforts to create an art that would enlighten mankind. What is marvelous about this particular discourse is the level of Vincent's optimism and his sense of empowerment. Elsewhere, to be sure, he recognizes the ostracism and misunderstanding, the spiritual

harrowing, that both Christ and the modern artist may share, but here he admires Christ as an "extraordinary artist," whose ability lies in the art of making life. In observing and depicting nature, in pursuing truth in nature to offer man some consolation, some hope of/for life, the artist is a holy man, a Christ-type. Perhaps the vitality of *Irises* is more comprehensible if we assume that in the midst of his mental and physical suffering, Vincent was able to hold on to this ideal.

Prior to his serious mental health problems, Van Gogh had compared himself to another artist-monk, whose history and work bear some similarity to Vincent's. Hugo van der Goes was a successful sixteenth-century Flemish painter who, having suffered the loss of the love of his life, withdrew to the confines of a monastery, where he subsequently suffered from a debilitating mental illness.[112] We do not know if Vincent read the reasonably popular 1872 biography of Van der Goes, but as early as 1873 he did mention a painting by the author's brother, Emile Wauters, entitled *The Madness of Hugo van der Goes* (figure 46). More than a decade later, in July and again in October of 1888, Vincent wrote Theo comparing himself somewhat jokingly to Van der Goes as depicted in the Wauters painting.

> Not only my pictures, but I myself have become haggard of late, almost like Hugo van der Goes in the picture by Emil Wauters. Only, having got my whole beard carefully shaved off I think that I am as much like the very placid priest in the same picture as like the mad painter so intelligently portrayed therein. And I do not mind being rather between the two, for one must live. (Vincent to Theo, Arles, ca. July 25, 1888, 514)

> I am not ill, but without a slightest doubt I'd get ill if I did not eat plenty of food and if I did not stop painting for a few days. As a matter of fact, I am again pretty nearly reduced to the madness of Hugo

46. Emile Wauters (Belgian, 1846–1933), *The Madness of Hugo van der Goes*, 1873.
 Oil on canvas, 186 × 275 cm (73¼ in. × 9 ft.¼ in.). Brussels, Royal Museum of
 Fine Arts, 2519.

van der Goes in Emil Wauters's picture. And if it were not that I have
almost a double nature, that of a monk and that of a painter, as it were,
I should have been reduced, and that long ago, completely and utterly,
to the aforesaid condition.

Yet even then I do not think that my madness would take the
form of persecution mania, since when in a state of excitement my
feelings lead me rather to the contemplation of eternity, and eternal
life. (Vincent to Theo, Arles, ca. October 21, 1888, 556)

When finally Van Gogh (whose name sounds eerily similarly to Van
der Goes) was faced with a similar fate, the jokes stop; perhaps dur-
ing that first week confined to the asylum, the analogy hit too close to
home. From our distant vantage point the comparison is fascinating.

Art historians writing of Van der Goes have used language similar to that found in the hyperbolic literature about Van Gogh; Erwin Panofsky described Van der Goes as "the first artist to live up to a concept unknown to the Middle Ages but cherished by the European mind ever after, the concept of a genius both blessed and cursed with his diversity from ordinary human beings" and made connections between the artist's style and his mental health.[113] The parallels had to have been striking for Van Gogh: two artists who sacrificed all for their art—sanity, companionship, freedom—and both of whom retreated to a monastery.[114]

Van der Goes's works, known in the nineteenth century through prints, have been admired in part for their remarkable botanical depictions; irises appear prominently in more than one painting, and the iris seems to have been Van der Goes's favorite flower. His masterpiece, the Portinari Altarpiece (one of the few works by a Northern artist described by Vasari; see figure 12), features meticulously described irises (both blue and white) in a vase in the center foreground. The Monforte Altarpiece (*Adoration of the Magi*) now in the Gemäldegalerie, Berlin, has a large clump at the left edge, while in the small devotional work *The Fall of Man* (which entered the collection of the Kunsthistorisches Museum in Vienna in 1884; figure 47) irises are prominently placed in the center foreground.[115] Had Van Gogh known his predecessor's paintings, and it is not clear that he did, those irises and the two artists' comparable situations would no doubt have resonated with him when he saw the lovely flowers growing in the walled garden of Saint-Paul-de-Mausole.

Another, but very different, monk who found solace for a mental breakdown in a walled garden can be found in Émile Zola's *La Faute de l'Abbé Mouret* (*Abbé Mouret's Trangressions*, 1875). The abbé of the title suffered hallucinations and a breakdown and was nursed back to health by a young woman within the walls of an overgrown garden;

Hugo van der Goes, *The Fall of Man*, ca. 1470. Oil on panel, 33.8 × 23 cm (13¼ × 9 in.).
Vienna, Kunsthistorisches Museum, GG 5822 A. Photo: Erich Lessing / AR, N.Y.

while in this idyllic, protected (and, for the abbé, amnesiac) realm they fell in love. Vincent referenced Le Paradou, the walled garden of the novel, following a visit to a garden the previous year.

> The two of us explored the old garden... If it had been bigger it would have made me think of Zola's Paradou, great reeds, vines, ivy, fig trees, olive trees, pomegranates with lusty flowers of the brightest orange, hundred-year-old cypresses, ash trees and willows, rock oaks, half-demolished flights of steps, ogive windows in ruins, blocks of white rock covered in lichen and scattered fragments of collapsed walls here and there among the greenery. (Vincent to Theo, Arles, ca. July 9, 1888)

In describing the garden of the novel, Zola catalogued the flowers and plants, including spilling irises and thickets of lilac. Certainly through the lens of Le Paradou is one way that Vincent saw the garden at Saint-Paul-de-Mausole. Tsukasa Kodera and Judy Sund have both convincingly argued that though he did not make specific reference to Le Paradou while in Saint-Rémy, in his mind he connected the literary garden with the garden of his paintings when he wrote about his "undergrowth" pictures, paintings of the shadowed, overgrown areas underneath the trees in the garden.[116] He compared the first of these compositions—the now-lost painting *A Corner in the Garden of Saint-Paul Hospital* (F609), known to us through the drawing *Trees with Ivy in the Garden of the Asylum* (figure 48)—to a cheap, popular print "depicting age-old love nests in the greenery."[117] Zola's descriptions of his garden include many overgrown, shady corners: "a cool, shady spot hidden away in the midst of an impenetrable jungle, and it is so marvellously [sic] beautiful that anyone who reaches it forgets all else in the world."[118] Shady romantic interludes do not seem possible in our patch of sun-soaked, enthusiastic irises, but perhaps the abbé's

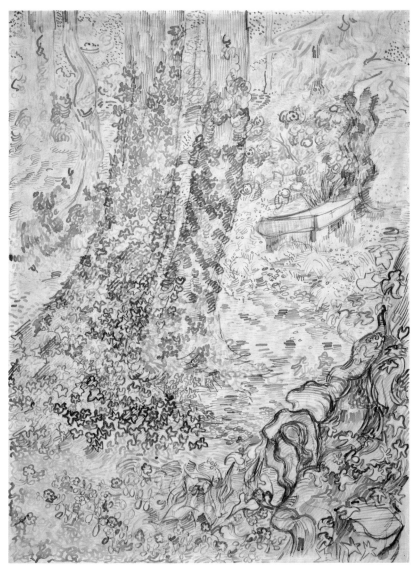

48. Vincent van Gogh, *Trees with Ivy in the Garden of the Asylum*, June–July 2, 1889.
 Reed pen, pen, and ink, graphite on wove paper, 62.3 × 47.1 cm (24¹/₂ × 18¹/₂ in.).
 Amsterdam, Van Gogh Museum, d439 V/1962 (F1522).

rejuvenation of health and spirit within the garden may enlighten our perception of the dynamism of the flowers in the face of the artist's struggles.

> The first touch of the soil gave him a shock; life seemed to rebound within him and to set him for a moment erect, with expanding frame, while he drew long breaths . . . He was being born anew in the sunshine, in that pure bath of light which streamed upon him . . . his senses hurriedly unclosing, enraptured with the mighty sky, the joyful earth, the prodigy of loveliness spread out around him. This garden, which he knew not only the day before, now afforded him boundless delight. Everything filled him with ecstasy, even the blades of grass. (*Abbé Mouret's Transgressions* [New York, 1915], pp.116–17)

The hope of a return to health in the protected haven of the garden such as the broken abbé experienced does not seem far from *Irises*. Zola's juxtaposition of the abbé's church-regulated life and his life in the garden, where nature helps man heal and return to his more primitive, essential self, echoes some of what we have seen in Van Gogh's own ideologies.

In the absence of mental hospitals prior to the eighteenth century, monasteries frequently became places for the care of the mentally disabled.[119] Although the gardens of religious structures were originally intended for contemplative use in monastic life, progressive medical treatises in the nineteenth century encouraged the exposure of mental patients to nature.[120] Thus, while the administration of the asylum at Saint-Rémy does not appear to have viewed the park as worth maintaining,[121] Van Gogh was not alone in believing the contemplation of nature—particularly the somewhat cultivated, gentled nature of a garden—to be beneficial to one's mental and physical health.

When I send you the four canvases of the garden I am working on, you will see that, considering my life is spent mostly in the garden, it is not so unhappy. (Vincent to Theo, Saint-Rémy, late May 1889, 592)[122]

Can you see a blade of grass from your apartment? I hope so. (Vincent to Theo, Arles, ca. February 22, 1889, 578)

In the nineteenth century, the notion of a restorative garden extended beyond the care of the ill to the soothing of the urban and suburban dwellers who at the weekend boarded trains bound for the countryside to relieve themselves from the stress of the city by seeing more than "a blade of grass." The increase in the number of paintings of gardens (and their market success) should in part be seen in this context—as bringing a token bit of green, sunshine, and flowers into an urban home. Gardens, nature created for the consumption of man, were depicted as spaces within which men, women, and children could move, associate, and promenade. Monet's *Gladioli* (figure 49), like *Irises*, displays riotously growing flowers but includes a fashionably dressed female strolling in the background. Van Gogh also painted in this mode while in Paris and Arles; *Courting Couples in the Voyer d'Argenson Park in Asnières* (figure 50) includes the requisite strolling couple, though Van Gogh chose to depict working-class figures instead of the more fashionable *flâneurs*. Edouard Manet, Van Gogh, and others also painted gardens that, though emptied of figures, make space—a path, a bench—to accommodate or anticipate them (figure 51). In Saint-Rémy, three of Vincent's first four pictures, *Lilacs* (see figure 4), *The Garden of the Asylum at Saint-Rémy* (see figure 39), and the lost *A Corner in the Garden of Saint-Paul's Hospital* (F609), are more in this vein, that is, open to romantic trysts. However, the riotous profusion of flowers in Vincent's earlier *Garden of Flowers* (figure 52), as in *Irises*, allows no room for perambulation.

49. Claude Monet (French, 1840–1926), *Gladioli*, ca. 1876. Oil on canvas, 101.6 × 83.6 cm (22 × 32½ in.). Detroit Institute of Arts, City of Detroit Purchase. Photo: BAL.

50. Vincent van Gogh, *Courting Couples in the Voyer d'Argenson Park in Asnières*, June/ July 1887. Oil on canvas, 75 × 112.5 cm (29½ × 44¼ in.). Amsterdam, Van Gogh Museum, s0019V/1962 (F314). Photo: Vincent van Gogh Foundation.

51. Edouard Manet (French, 1832–1883), *The Bench in the Garden of Versailles*, 1881. Oil on canvas, 81 × 65 cm (31⅞ × 25⅝ in.). Private collection. Photo: Christie's Images / BAL.

52. Vincent van Gogh, *Garden of Flowers*, July 1888. Oil on canvas, 92 × 73 cm
(36¼ × 28¾ in.). Private collection (F430). Photo: Bridgeman / Giraudon / AR, N.Y.

Viewers are pushed to the margin and more and more of the picture plane is covered with blooms. Although *Irises* also could be classified as a "garden painting," here the artist went even further and cut out the surroundings entirely—no horizon, no sky, no path, no entry, no garden; the irises hardly make room for any other plant. But should we view *Irises* as simply depicting rejuvenating, exuberant, unrestrained nature? If Van Gogh had stood up, backed up, and given the wider view, what would we have seen?—the walls enclosing the garden, the walls of the asylum itself, his fellow inmates and caretakers.

> Yesterday I drew a very big, rather rare night moth, called a death's head, its colouring of amazing distinction, black, grey, cloudy white tinged with carmine or vaguely shading off into olive green; it is very big...To paint it I had to kill it, and it was a pity, the beast was so beautiful. (Vincent to Theo, Saint-Rémy, May 22, 1889, 592)

Walls of refuge can just as easily be the walls of a prison. The monastery of Saint-Paul was named "Mausole" for its proximity to the Roman mausoleum at Glanum (*mausolée* being the French word for mausoleum or tomb). The Félibrist writer Paul Mariéton visited Saint-Paul in August 1888 and in 1890 published the notes from his tour around Provence. Describing the cloister as *étouffant* (stifling, oppressive), he could hardly wait to leave; it reminded him of an Italian singer who conveyed the "melancholy of death."[123] While Van Gogh and Marieton's paths never crossed (the writer's visit occurred before Vincent's arrival at the asylum), and it seems unlikely that Vincent would have seen his published journal, Marieton's impressions provide a valuable second opinion that validates the artist's negative feelings toward the architecture.[124]

How eerily appropriate it is that the white cemetery iris should bloom in the garden of an asylum named for a mausoleum, and how

easy it is for us to understand Vincent's feelings of being entombed, or buried alive, in these "old cloisters," where he could hear other patients "howl or rave continually."[125] At least one recurring motif from his paintings in Saint-Rémy, the cypress, incorporated within it concepts of death and transcendent immortality.[126] Van Gogh described cypresses as "funereal" (Vincent to Theo, Arles, ca. September 27, 1888, 541) and "as beautiful of line and proportion as an Egyptian obelisk...a splash of black in a sunny landscape" (Vincent to Theo, Saint-Rémy, June 25, 1889, 596).

The concepts of death and transcendent immortality also inform *Irises*. The tradition of flower painting includes a mode known as a *vanitas*, derived from Ecclesiastes 1:2: "Vanitas vanitatum, omnia vanitas"—"Vanity, vanity, all is vanity." In a *vanitas* still life, the objects are assembled to suggest the ephemerality of life and the inevitability of death: flowers blooming and withering, timepieces, short-lived butterflies, skulls, fragile bubbles, a snuffed candle. A *vanitas* also urges the renunciation of the world by indicating the pointlessness and corruptibility of material objects (and by association, human flesh). Within these images, objects and flowers may also make reference to Christian hopes of resurrection, through the symbolism of specific flowers or the inclusion of a crucifix or a Bible.

Although it is not a flower painting, Barthel Beham's *Vanitas* (figure 53), which it seems unlikely Van Gogh knew, embodies the same theme and presents the iris in a context we have not yet seen: a complicated allegory of death in which a nude woman stands upon her tomb, shadowed by death and grasping a tall blooming iris. The flower again represents the redemptive pain of the Virgin and Christ but in the context of the inevitability of death and the corruptibility of the body. The scriptural references at the bottom are common to the *vanitas* theme; all are variations on "For all flesh is as grass, and all the glory of man as the flower of grass. The grass withereth, and

53. Barthel Beham (German, 1502–1540), *Vanitas*, 1540. Oil on wood panel, 58.5 × 42 cm (23 × 16½ in.). Hamburg, Kunsthalle, 328. Photo: Elke Walford / Bildarchiv Preussischer Kulturbesitz / AR, N.Y.

the flower thereof falleth away" (1 Peter 1:24). Like the cypress in Van Gogh's paintings, the iris can play a dual role; it reminds us of the opportunity for eternal salvation through the suffering of Christ, but like grass it withers and loses its bloom. Van Gogh's *Irises* bud, bloom, and begin to fade, representing, from a *vanitas* standpoint, the full range and cycle of life, allowing us to contemplate either life's brevity and the inexorability of death or the constant renewal of nature and the hope of spiritual salvation.

While Van Gogh described conditions at the asylum and hinted at the horror an intelligent, talented man, lucid between attacks, must have felt in these surroundings, he did so with compassion for his fellow inmates and saw in them a humanizing of his own disease.

> Though here there are some patients very seriously ill, the fear and horror of madness that I used to have has already lessened a great deal. And though here you continually hear terrible cries and howls like beasts in a menagerie, in spite of that people get to know each other very well and help each other when their attacks come on. (Vincent to Jo, Saint-Rémy, ca. May 10–15, 1889, 591)

Vincent's constant striving for hope in the face of fear seems commensurate with the insistent vitality of the plants in *Irises*, living despite their surroundings, despite their neglect, without any notions of death or the tomb that might lurk in his—our—subconscious. And yet lurk it does, in the way he expressed his gratitude for his brother's support—"If I were without your friendship, they would remorselessly drive me to suicide, and however cowardly I am, I should end by doing it"[127]—and in our knowledge of how he ended his life fourteen months later.

Planting himself in the Mediterranean landscape, Van Gogh arrived at a strange confluence, perceiving his surroundings as at

once biblical, Provençal, and Japanese. *Irises* is an emblem both of spiritual suffering and of hope for transcendence. These tenacious, independent flowers of Provence, vigorously blooming in the hot sun, are to be enjoyed for their beauty, their practical uses, and as the Provençal sister-flower of the Japanese iris. These "complicated combinations"—associations, context, potential meanings, and motivations—lead us down many paths, but all begin and end with the artist seated on the ground in front of irises growing in a garden. He himself described *Irises* only as one of a group of paintings he deemed "more studies from nature than subjects for pictures." His brother called the painting no more than "a beautiful study full of air and life," contrasting it to *Starry Night* (see figure 76), where Theo thought Vincent was looking too far into the metaphysical. But Van Gogh was an amazingly well-read, thoughtful, even philosophical man, and we should not assume that his surviving letters reveal the entirety of his thoughts and knowledge. In the end, we can only scratch the surface of what this image may have meant to him at that moment. But given that the brothers themselves described the painting only as a study from nature, perhaps all the potential "combinations" are merely our own.

I gave him as a keepsake a still life which had annoyed the good gendarmes of the town of Arles, because it represented two bloaters (fish), and as you know they, the gendarmes, are called that. You remember that I did this same still life two or three times in Paris, and exchanged it once for a carpet in the old days. That is enough to show you how meddlesome and what idiots these people are. (To Theo, Arles, March 24, 1889, 581)

Perhaps Gertrude Stein was correct when she opined that sometimes "a rose is a rose is a rose," a fish is a fish, and a flower is only a flower.

CHAPTER 4

A CERTAIN POINT OF VIEW

But never mind, I think I am not going to urge you too much to read
books or dramas, seeing that I myself, after reading them for some
time, feel obliged to go out and look at a blade of grass, the branch
of a fir tree, an ear of wheat, in order to calm down. (Vincent to
Wilhelmina, Saint-Rémy, July 2, 1889, W13)

Irises does not fall neatly into one of the usual categories of paint-
ing. It is not a still life; the plants are still living, still growing up out
of the earth. It is not a landscape in the traditional sense—it has no
horizon, no significant depth or breadth, only earth and and a wall of
flowers. The painting could be accepted as simply a "nature study,"
as Van Gogh himself described it, but this implies spontaneity and a
lack of considered composition at odds with the painting's degree of
formality and monumentality. Furthermore, Van Gogh's choice of a
large "size 30" canvas, the same size that he had earlier used for more
panoramic views, suggests a certain ambition, although when he sent
it to Theo in July, he relegated it to a stack of seven works that were
"more studies from nature than subjects for pictures," saying, "and it
is always like that, you must make several before you can get a whole
that has character."[128] Still, he must have felt it to be successful on

some level as a finished picture; of the more than 135 paintings that he created at Saint-Rémy, we know of only six or so that were signed, one of which was *Irises*. It might seem that Van Gogh was inventing a whole new genre, something that could be called a living still life (*nature vivante* instead of *nature morte*) or a botanical portrait, but he actually had a few precedents for his face-to-flower viewpoint and his cropped, horizonless composition. Although they are disparate in style, these precedents—among them Japanese art, European illustrated herbals, Albrecht Dürer—also fit within Vincent's ideology concerning art and the role of the artist.

> If we study Japanese art, we discover a man who is undeniably wise, philosophical and intelligent, who spends his time—doing what? Studying the distance from the earth and the moon? No! Studying the politics of Bismarck? No! He studies . . . a single blade of grass. But this blade of grass leads him to draw all the plants—then the seasons, the grand spectacle of landscapes, finally animals, then the human figure. (Vincent to Theo, Arles, September 24, 1888, 542)

Vincent admired Japanese art. He and his brother collected literally hundreds of Japanese prints and discussed them as a financial investment and the foundation of a possible business venture. He hung them on the walls of his studio at least as early as 1885, while living in Antwerp, continued to seek them out in Paris, and carried some with him to the south of France. His love of things Japanese colored his view of the world; where today we may look about us in Provence and see Van Gogh, he saw "pure Hokusai." He traced and transferred the compositions of a few woodblock prints, including Hiroshige's *The Flowering Plum Tree*, painting them in his own idiom and then incorporating the ideas gleaned from this exercise into his

54. Vincent van Gogh, *The Flowering Plum Tree* (after Hiroshige), 1887. Oil on canvas, 55 × 46 cm (21⅝ × 18⅛ in.). Amsterdam, Van Gogh Museum. Photo: Hermann Buresch/ AR, N.Y.

55. Vincent van Gogh, *Orchard in Blossom with View of Arles*, April 1889. Oil on canvas, 72 × 92 cm (28⅜ × 36¼ in.). Munich, Neue Pinakothek (F516). Photo: Bridgeman / Giraudon / AR, N.Y.

art (figure 54). For *Orchard in Blossom with View of Arles* (figure 55), he implemented the print's framing device of cropped tree trunks flattened up against the picture plane with a landscape that extends far into the distance.

But Van Gogh's interest in Japan and Japonisme extended beyond visual concerns, informing his utopian ideas about the artist and his world. His conception of Japanese culture and the Japanese artist was not based on reality but was lifted in part from texts by the Goncourt brothers, Siegfried Bing, Pierre Loti, and others and then made to fit his own idealism.[129] In Vincent's view, the Japanese artist was "wise, philosophical, intelligent"; he lived in harmony with other artists, exchanging artwork and ideas as Vincent dreamed he and his companions would in his "Studio of the South." Perhaps most importantly, the Japanese artist engaged in a close study of nature, through which he achieved a higher level of spirituality and artistic expression. Like the "blade of grass,"[130] *Irises* offers up a hand-to-hand contemplation of the smaller details of nature, bringing the viewer face-to-face with things often overlooked and, perhaps, promising greater truths about art, man, and the universe.[131]

> So come, isn't what we are taught by these simple Japanese, who live in nature as if they themselves were flowers, almost a true religion?
>
> And one cannot study Japanese art, it seems to me, without becoming merrier and happier, and we should turn back to nature in spite of our education and our work in a conventional world. (Vincent to Theo, Arles, September 24, 1888, 542)

The ideal of studying a simple blade of grass is an invitation to sit upon the ground. Down among the plants, we live for a moment as if we "were flowers." The practice of that "true religion" would have been a positive, reassuring alternative for Van Gogh on finding him-

self within the oppressive confines of a building that represented the religion he relegated to superstition. Japanese art and an idealized immersion in nature offered consolation and hope—a new religion—and, perhaps, escape from the harsh realities of the world.

In *Irises*, the macroscopic viewpoint, strong outlines, and particularly the cropped stalks at the lower right foreground, all tell of Van Gogh's attention to Japanese prints. Similar compositions can be found in the work of Hokusai and Hiroshige (figures 56 and 57), both of whom Van Gogh admired. In the prints, however, such cropped branches are usually set against a far distant landscape or an empty background—just as Van Gogh would silhouette branches against a blue sky in his *Almond Blossom* (figure 58). Following the opening of trade between Europe and Japan in the 1850s,

56. Katsushika Hokusai (Japanese, 1760–1849), *Iris and Grasshopper*, ca. 1830. Color woodblock print on paper, 24.2 × 36 cm (9½ × 14³/₁₆ in.). Minneapolis Institute of Arts, Bequest of Richard P. Gale, 74.1.212.

57. Utagawa [Ando] Hiroshige (Japanese, 1797–1858), *Horikiri Iris Garden*, from
the series 100 Famous Views of Edo, 1857. Polychrome on woodblock print,
35.6 × 23.9 cm (14 × 9⅜ in.). Ithaca, N.Y., Cornell University, Herbert F. Johnson
Museum of Art, Bequest of William P. Chapman Jr., Class of 1895, 1895.57.56.

58. Vincent van Gogh, *Almond Blossom*, 1890. Oil on canvas, 73.5 × 92 cm (28¹⁵/₁₆ ×
 36¹/₄ in.). Amsterdam, Van Gogh Museum (F671). Photo: AR, N.Y.

knowledge of Japanese art rapidly expanded in Paris. In addition to ukiyo-e prints, other objects, including lacquerware, illustrated books, and folding screens festooned with details of nature, were avidly sought and acquired by collectors. In a portrait by James Tissot from 1866, the sophisticated taste of the Marquise de Mira-mon is represented not just by her elegant clothing and furnish-ings but by the inclusion of a Japanese folding screen depicting cranes (figure 59). Clearly a few gold-grounded paintings by art-ists such as Ogata Kōrin had made their way to Europe.[132] Two pairs of Kōrin's most famous folding screens depict iris gardens; in both, the water in which the irises grow is represented abstractly by gold leaf, which covers the entire image such that there is no horizon line (figure 60). It would have been impossible for Van Gogh to have seen these screens: one set never left Japan (it remains in the Nezu Museum and is considered a national treasure), while the other was acquired by the Metropolitan Museum of Art in New York only in the twentieth century. The New York screens were, however, repro-duced in the second of two volumes of a well-known illustrated book of woodcut prints, *Kōrin Hyakuzu*, which catalogued Kōrin's mas-terpieces (figure 61).[133] Produced in Japan in the early nineteenth century, these books were themselves valued as artworks and sought after by European collectors decades later. While the simple line drawings lack the startling effect of the gold ground—its reflective nature suggesting both water and three-dimensional space despite its insistently two-dimensional character—they nonetheless offer up a flat, horizonless field of irises. The most Japanese, and yet also the most modern, aspect of Van Gogh's flowers may be that they are in effect a screen, or wall, of irises; they exist on the surface of the can-vas (and even project out into the viewer's space) rather than reced-ing into a landscape, which has the effect of bringing viewers as close "as if they themselves were flowers."

59. Jacques-Joseph (James) Tissot (French, 1836–1902), *Portrait of the Marquise
 de Miramon, née Thérèse Feuillant*, 1866 Oil on canvas, 128.5 × 76 cm (50⁹/16 ×
 29¹⁵/16 in.). Los Angeles, JPGM, 2007.7.

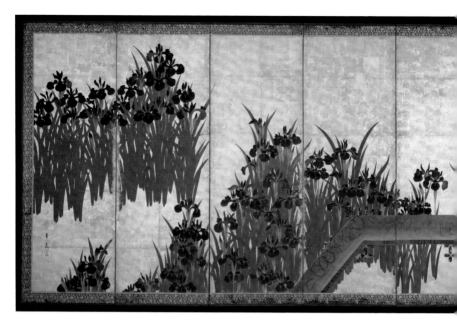

60. Ogata Kōrin (Japanese, 1658–1716), *Eight-Planked Bridge (Yatsuhashi)*. One of a pair of six-fold screens, ink and color on gilded paper, 179.1 × 371.5 cm (5 ft. 10½ in. × 12 ft. 2¼ in.). New York, Metropolitan Museum of Art, Purchase, Louisa Eldridge McBurney Gift, 1953 (53.7.1-2). Photo: Art Resource, N.Y.

61. Ogata Kōrin, *Irises* screen, from Sakai Hōitsu, *Kōrin Hyakuzu Kōhen* [illustrated book].
London, Victoria and Albert Museum, E.2922.2923-1925.

But Van Gogh's painting is clearly not a precise transcription of Japanese art. The medium itself imposes differences, particularly given the way Vincent handled paint. Rather like the Japanese irises they depict, Japanese prints are crisp and elegantly linear. Kōrin's paintings seem slick, precious, almost delicate, next to Vincent's rough, fleshy, jostling flowers. Van Gogh reinforced objects with bold outlines, but his thick application of paint gave the surface a tangible, almost sculptural, rather than graphic, quality.[134] Even in a photographic reproduction the ridges of paint formed by the brushstrokes are visible. Looking at the blooms in the lower right in raking light, we can see a contradictory texture, indicating that he reworked this area after the paint had dried sufficiently (figure 62). The two flowers second from the right, one above the other, have been brought forward to cover the tall stalk that extends above them. Any spatial depth that had existed in this already shallow field was further collapsed by this layering and by the extension of the tall stalk up into the realm of

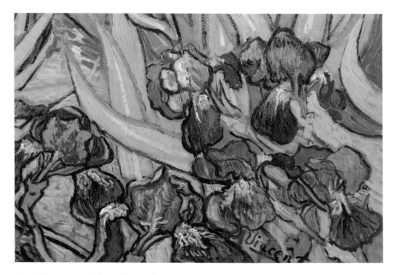

62. Photograph of *Irises* (figure 1), lower right quadrant in raking light.

the other bank of flowers, confusing its point of origin. Other flowers were added later, where none had originally been planned, for example, the more cursory, darker flowers to the right and left of the white iris. The tendency is to think of Vincent painting everything in one "go," in some sort of inspired, energetic outburst. And he does seem to have worked that way at times; he certainly perceived it as a positive value in the process of Japanese artists, whose simpler "intuitive"[135] work appeared to him to be quick and free from the impediments or restraint of Western tradition or thought.

> The Japanese draw quickly, very quickly, like a lightning flash, because their nerves are finer, their feeling simpler. (Vincent to Theo, Arles, June 5, 1888, 500)
>
> I have at times worked excessively fast. Is it a fault? I can't help it. For instance, I painted a size 30 canvas, the "Summer Evening," at a single sitting...Aren't we seeking intensity of thought rather than tranquility of touch? But under the given conditions of working spontaneously, on the spot, and given the character of it, is a calm, well-regulated touch always possible? Goodness gracious—as little, it seems to me, as during an assault in a fencing match. (Vincent to Émile Bernard, Arles, June 24, 1888, B09)
>
> I envy the Japanese the extreme clarity of everything in their work. It is never dull and it never seems to be done in too much of a hurry. Their work is as simple as breathing, and they do a figure in a few sure strokes as if it were as easy as doing up your waistcoat. (Vincent to Theo, Arles, September 24, 1888, 542)

The earth in front of the irises was worked wet in a variety of colors, each brushstroke blending them directly on the canvas. The composition itself appears to have been drawn/painted first in blue outline onto the canvas ground;[136] no study or preparatory drawing

is known. After the colors had been laid in, outlines were reinforced, again in blue. But Van Gogh clearly went back when the paint was dry and made considered additions and alterations. Thus, *Irises* cannot be seen as a simple study, whipped up in a day's spiritually ecstatic encounter with nature, any more than Hiroshige's image can be considered an unmediated reflection of a moment's gaze. In neither case was the process of creation "as easy as doing up your waistcoat." Van Gogh laid out a complex composition, executed it, and then edited it days or even weeks later to satisfy his artistic aims.

Van Gogh did not have to look as far as Japan for examples of ground-level engagement with nature. European precursors also engaged in lowered, macroscopic viewpoints of nature and, like Van Gogh, included the earth—an aspect that tends to be absent in Japanese prints, in which stems are cut off before they reach the ground.[137] European painting offers other avenues of understanding his approach to *Irises*. The birth of flower painting has been traced to the appearance of illustrated herbals (encyclopedias of plants and their medicinal uses), particularly the collections of flowers sometimes called *florilegia*,[138] in the sixteenth and seventeenth centuries.[139] The initial purpose of herbals and florilegia was documentary and taxonomical, but their plates became prized as works of art. Crispijn van de Passe's illustrations for *Hortus floridus*, which is considered a horticultural masterpiece, arranged plants in silhouette, both free of the earth with roots exposed and growing from the earth (figures 63 and 64). In the complicated culture of the Renaissance, a burgeoning interest in science fueled further artistic examination of the natural world.[140] Leonardo da Vinci, Jacopo Bellini, and Albrecht Dürer (among others) made drawings that were the result of serious, objective study of nature. Most often, however, these studies functioned as preparatory drawings for paintings, usually religious works, and once transferred to their larger context generally served

63. Crispijn van de Passe (Dutch, 1565–1637), *Aconitum*, plate from *Hortus Floridus* (Arnheim, 1614). Hand-colored engraving, 14 × 20.3 cm (5½ × 8 in.). Palo Alto, Calif., Lyons Limited Antique Prints.

64. Crispijn van de Passe, *Chamaeiris colore caeruleo violaceo*, plate from *Hortus Floridus* (Arnheim, 1614). Hand-colored engraving. New York, Ursus Books and Prints.

65. Albrecht Dürer (German, 1471–1528), *Iris*, ca. 1503. Watercolor on paper,
77.5 × 31.3 cm (30½ × 12⅜ in.). Bremen, Kunsthalle, Kupferstichkabinett.
Photo: Lars Lohrisch / Der Kunstverein in Bremen.

some symbolic purpose. Dürer's *Irises* (figure 65), a life-size study drawn on two pieces of paper glued together, was used in an altarpiece by his studio.[141] But even within Dürer's own lifetime these studies from nature came to be appreciated as independent works of art. Hans Hoffmann had access to, copied, and was inspired by Dürer's drawings in a Nuremberg private collection and made something of a career of Dürer-ish nature studies for art connoisseurs. For his *Hare in the Forest* (figure 66), he combined Dürer's famous drawing of a hare with other studies of plants; this charming view of forest underbrush appears to have been observed firsthand, but it is an assembled fiction.[142] In his *Large Piece of Turf* (figure 67), Dürer drew dandelions in

66. Hans Hoffmann (German, ca. 1530–1591), *A Hare in the Forest*, ca. 1585. Oil on panel, 62.2 × 78.4 cm (24½ × 30⅞ in.). Los Angeles, JPGM, 2001.12.

67. Albrecht Dürer, *Large Piece of Turf*, 1503. Watercolor and tempera on paper mounted on cardboard, 40.3 × 31.1 cm (15⁷/₈ × 12¹/₄ in.). Vienna, Albertina, Graphische Sammlung. Photo: Erich Lessing/ AR, N.Y.

bud, grasses gone to seed, and identifiable but particularized weeds, presenting a specific, insignificant patch of ground with remarkable casualness. In its seemingly random cropping at the edges the image is quite "modern."[143] *Large Piece of Turf* may be the most famous study of a blade (or tuft) of grass ever made; reproductive prints of the watercolor would have been available to Van Gogh.[144]

Dürer continued to be admired for centuries after his death, but in the nineteenth century his work and his biography enjoyed heightened attention. In the mid-nineteenth century, the Nazarenes had celebrated Dürer in their quest for a "German" art that was more primitive and spiritual. In France, Dürer had been discovered by authors such as Victor Hugo, who associated him with a romanticized notion of the Gothic. His print *Melancholia* had been widely influential for its image of the artist as a suffering spirit; Van Gogh himself wrote of *Melancholia* and painted a portrait of Dr. Gachet posed in similar fashion.[145] Vincent had read both a biography of Dürer and the artist's own writings, in which he found and followed instructions for building a "perspective frame,"[146] and he went to the Rijksmuseum in Amsterdam to look at its collection of Dürer's prints. Theo wrote Vincent from Paris (January 22, 1890) that he had spent an evening with a friend looking at the engraver Amand-Durand's *Oeuvre d'Albert Dürer*, and it seems quite plausible that the Van Goghs knew the studies of Dürer's drawings by Charles Ephrussi, editor of the *Gazette des Beaux Arts* and friend of Renoir's.[147] The nineteenth century's image of Dürer as humble, devout, and hard-working, a "simple man of God," with a renowned attention to nature, in short, a fellow artist-monk, would have appealed to Vincent. To sit on the ground and study nature at its own level (Dürer appears to have been practically lying on his stomach when he drew his *Large Piece of Turf*) requires an attitude of respect for the subject coupled with humility. When Van Gogh mentioned Dürer's works in his letters, he often associated the

woodblock prints with some romantically Gothic view—twisted tree roots and a vine-covered old church, for example.[148] We have speculated that the surroundings of a medieval monastery could have spurred, or at least complicated, Vincent's interest in irises as a subject; perhaps its Gothic architecture also stirred memories of other irises and works by Dürer, the "simple man of God."

Other paintings from within the tradition of Dutch flower painting also focus on the corner of a garden or the undergrowth of the forest floor but on a scale closer to that of *Irises*. A panel by Jacob Gerritsz. Cuyp made ground-view botanical illustration decorative by removing it from the context of a book, aggrandizing the image, and placing it on a wall (figure 68). Otto Marseus van Schrieck, Rachel Ruysch, and others specialized in portraying living plants at eye-level (figures 69 and 70). Generally a single type of plant dominated, with insects, reptiles, and other vegetation playing a supporting role in the scene, which was set against a shallow, shadowed background (indeterminate forest, rock wall), though at times a piece

68. Jacob Gerritsz. Cuyp (Dutch, 1594–1650), *Tulips*, 1638. Oil on panel, 38 × 76 cm (15 × 30 in.). Dordrechts, Germany, Dordrechts Museum, DM/977/523.

69. Otto Marseus van Schrieck (Dutch, 1619–1678), *Still Life with Thistles, Reptiles, Insects, and Butterflies*, ca. 1670. Oil on canvas, 125.1 × 101.3 cm (49¼ × 39⅞ in.). Ithaca, N.Y., Cornell University, Herbert F. Johnson Museum of Art, Gift of Mr. and Mrs. H. A. Metzger, Class of 1921, 60.195.

132

70. Rachel Ruysch (Dutch, 1664–1750), *Forest Floor*, 1687. Oil on canvas, 47 × 40 cm
(18½ × 15¾ in.). Oxford, Ashmolean Museum, WA1940.2.64.

of sky and/or a corner of a distant landscape opened out a portion of the composition. As in the Hoffmann *Hare*, these compositions bring together combinations of plant life impossible in nature. Although the majority have a decorative feel, the amplification in scale of a corner of "nature" that might normally be overlooked suggests the possibility of some weightier purpose; Van Schrieck's humble *Still Life with Thistles, Reptiles, Insects, and Butterflies*,[149] neither traditionally beautiful nor exotic, is imbued with dignity and solemnity, even power. While the visual result in these paintings is different from those achieved by Japanese artists in their study of "a single blade of grass," the approach is similar, in that they are "artists who perceived nature's greatness in its humblest manifestations."[150] Irises have received more appreciation for their beauty than has the roadside thistle, but rarely have they been portrayed with more attention to *character* (if we can use that word for a plant) than in Van Gogh's painting: hopeful, exuberant, they contend with each other for place, turning this way and that to best display their finery. As is the case with Schrieck's *Thistles*, we are led to believe that there is more to *Irises* than an objective appreciation of an overlooked, neglected corner of a garden.

> The forest was marvelously beautiful in this attire, but I am not sure the most modest objects, the bushes and briars, tufts of grass, and little twigs of all kinds were not, in their way, the most beautiful of all. It seems as if Nature wished to give them a chance to show that these poor despised things are inferior to nothing in God's creation. (Jean-François Millet to Émile Gavet, December 28, 1865)[151]

Jean-François Millet, perhaps Vincent's greatest artistic hero, understood the spiritual and artistic potential of the insignificant blade of grass. Three of his pastels, *Primroses*, *Daffodils*, and *Dandelions*),[152] ground-level views of common plants growing in the verge,

are not pages from a sketchbook but finished works of art, reasonably large in size, and something of a departure from Millet's usual more traditional approach to landscape. *Dandelions* (figure 71) seems to us particularly striking, with its wall of greenery pushing behind the dandelions and the single yellow, still blooming dandelion hanging to one side. In *Primroses* (figure 72) and *Daffodils* the flowers glow out of the darkness, but the sunlit palette of *Dandelions* is, like *Irises*, dependent on intense, jewellike greens. Here and there, Millet also reinforced in black the contours of forms constructed in color—works in pastel are said to be painted, not drawn, since, as with painting, objects are built up with strokes of color. Conversely, Van Gogh "draws" with paint, changing his brushstroke to accommodate different textures and to achieve different effects. Defined by stripes of green, yellow, and black, the blades of grass in *Dandelions* are not unlike Van Gogh's own grass studies, which use similar strokes of black to underscore form and generate shadows. But though the two artists' approaches to picture-making are similar, the results are different. Millet's *Dandelions* gives an intimate peek at an enchanting, fairylike world, while Van Gogh's *Irises* blazes forth and almost overwhelms the viewer.

In June 1875, a fabulous collection of drawings and pastels by Millet was placed at auction at Hotel Drouot.[153] Van Gogh's opportunity to see these particular pastels was a revelatory moment for him.

> I don't know whether I have already written to you about it or not, but there has been a sale here of drawings by Millet. When I entered the hall of the Hôtel Drouot, where they were exhibited, I felt like saying, "Take off your shoes, for the place where you are standing is Holy Ground." (Vincent to Theo, Paris, June 29, 1875, 29)

Long before he decided to become an artist, Vincent had revered Millet, both the man and the work.[154] Alfred Sensier, Millet's biog-

71. Jean-François Millet (French, 1814–1875), *Dandelions*, ca. 1867–68. Pastel on tan wove paper, 40.6 × 50.2 cm (16 × 19³/₄ in.). Boston, Museum of Fine Arts, Gift of Quincy Adams Shaw through Quincy Adams Shaw Jr. and Mrs. Marian Shaw Haughton, 17.1524.

72. Jean-François Millet, *Primroses*, ca. 1867–68. Pastel on gray-brown wove paper, 40.3 × 47.9 cm (15¾ × 18⅞ in). Boston, Museum of Fine Arts, Gift of Quincy Adams Shaw through Quincy Adams Shaw Jr. and Mrs. Marian Shaw Haughton, 17.1523.

rapher,[155] described the artist as a humble, peasant painter—"paysan je suis né, paysan je mourrai"—living and working among his subjects. Although it was hardly a true description of a complex man, Sensier's characterization was nonetheless immensely appealing to Van Gogh, who had once elected to live as humbly as the miners he was teaching. Millet chose as his subject matter the rural countryside and its workers—at a time when both were increasingly under the impact of industrialization—and gave them a mythic, heroic quality in works that were quasi-biblical in aspect. Vincent himself saw Millet replacing his father, the pastor, as his spiritual leader, "a sort of prophet capable of interpreting the religious dimension of nature."[156] Millet's work offered Vincent solace. In his most desperate hours in the asylum, when he was not capable of doing his own work from nature, he reduced his artistic activity to copying and reinventing Millet's paintings from prints. The kinship between the Millet pastels, Dürer's *Large Piece of Turf*, Japanese prints,[157] and Van Gogh's *Irises* is more than a question of viewpoint; at least in Van Gogh's mind, they shared the same spiritual goals.

In his letters, however, Van Gogh associated Millet with Dürer, not spiritually but artistically. As early as 1883, he wrote to his friend Rappard and spoke of Dürer and Millet in one breath—with regard to prints.

> Take Millet's etching, "The Diggers," take an engraving by Albrecht Durer, above all take the large woodcut by Millet himself, "The Shepherdess"—then you see with full clarity what may be expressed by such a contour. (Vincent to Anton Rappard, May–June 1883, R37)

Contour (outline) had long been an important aspect of Van Gogh's art—perhaps because he began his career as he did, by teaching himself to draw from prints. This emphasis was reinforced by his

association with Émile Bernard, Louis Anquetin, and other artists of an avant-garde movement known as Cloisonnism. The critic Edouard Dujardin coined the group's name from cloisonné, medieval enamel work that used metal contours to frame and separate areas of color, but these artists were equally influenced by other media dominated by strong contours and flat, saturated colors, including stained-glass windows and Japanese prints.[158] They, like other avant-garde artists, were also attracted to the "primitive" folk-art woodcut prints known as *Images d'Epinal*. These inexpensive prints, intended for a less literate populace, were admired for their crude, colorful images of religious or historical subjects or scenes from popular novels. Writing to Bernard, Van Gogh reinforced his alignment with the Cloisonnists' artistic goals when he described his working methods.

> While working directly on the spot, I try to capture the essence in the drawing—then I fill the spaces demarcated by the outlines (expressed or not) but felt in every case, likewise with simplified tints, in the sense that everything that will be earth will share the same purplish tint. (Vincent to Émile Bernard, Arles, ca. April 12, 1888, B03).

The process Vincent described is useful to our understanding of the creation of *Irises*, which appears to have been constructed in a similar manner—outline first, color then filling the spaces, outlines reinforced as necessary. While Vincent was careful to emphasize his commitment to working in front of his subject, "the essence" he aimed to capture with drawn line appears to mean both the distilled, abstracted composition and the intrinsic nature of the subject. In a letter from the fall of 1889 to Theo, he wrote describing his *Olive Trees* (see figure 33), attempting to explain that the meaning, the emotion, was in the line and the contour.

These are exaggerations from the point of view of arrangement, outlines accentuated like those in old woodcuts... where these lines are tight and willed, there begins the painting, even if it should be exaggerated. (Vincent to Theo, Saint-Rémy, September 19, 1889, 607)[159]

Once again Van Gogh was asserting that style (here encapsulated in the character of the line) conveys expression of thought or emotion and higher principles. In *Irises*, his exaggerated contours set the leaves in motion and ruffled the petals, generating our perception of emotion and creating a truly *living* still life.

Millet's work is frequently associated with another group of painters whom Van Gogh admired, known as the Barbizon school. These artists, Théodore Rousseau and Narcisse Diaz de la Peña among others, shared with Millet and Van Gogh a love of the rural landscape. Taking their name from a village near the forest of Fontainebleau where they frequently practiced their art, the group was interested in the preservation of the region's historic landscape, a cause they pursued in part through painting. The forest's ancient oak trees had come under threat from tourism and commercial logging. Rousseau and others argued vociferously (and successfully) for the protection of a portion of the region in its wild, natural state. Their dedication to a naturalized landscape can be seen in a type of picture, known as a *sous-bois*, in which they specialized. The term literally means "under/within the forest," and these works presented a narrow, closely cropped peek under the canopy of trees, rather than a broad, all-encompassing prospect.[160] Despite their at times monumental scale, these paintings have surprising intimacy; the viewer is invited into the forest to explore its light-dappled, hidden places (figure 73). Pierre-Auguste Renoir's later *La Promenade* (figure 74) toys with a similar invitation to explore the privacy of the woods, but the pair of lovers in contemporary dress, negotiating their entry into

73. Théodore Rousseau (French, 1812–1867), *Forest of Fontainebleau, Cluster of Tall Trees Overlooking the Plain of Clair-Bois at the Edge of Bas-Bréau*, ca. 1849–55. Oil on canvas, 91.2 × 116 cm (35⁷/₁₆ × 45¹¹/₁₆ in.). Los Angeles, JPGM, 2007.13.

74. Pierre-Auguste Renoir (French, 1841–1919), *La Promenade*, 1870. Oil on canvas, 81.3 × 64.8 cm (32 × 25½ in.). Los Angeles, JPGM, 89.PA.41.

the foliage of the parklike setting, recalls as well the woodland frolics of eighteenth-century painters like Jean-Honoré Fragonard. Van Gogh's own views of woodland undergrowth, such as *Sous-bois* (figure 75), which he completed both in Paris and later in the garden at Saint-Rémy, have as much to do with the Barbizon tradition as they do with Zola's description of the garden of Le Paradou (see chapter 3). As Van Gogh enthused,

> Think of Barbizon, that story is sublime...The country formed them, they only knew, It is no good in a city, I must go to the country. I suppose they thought, I must learn to work, become quite different, yes, the opposite of what I am now. They said, I am no good now, I'm going to renew myself in nature. (Vincent to Theo, Drenthe, September–November, 1883, 339)

Here Van Gogh proposed the inversion of Mirbeau's premise that he forced nature to submit; on the contrary, nature is the transformative power (as it is in Zola's garden). Like those of the Barbizon painters, Van Gogh's *sous-bois* images are not small studies on paper intended for a connoisseur's cabinet but formal works in oil on canvas meant for exhibition. But while *Irises* shares this seriousness of artistic purpose and likewise raises a narrowly focused nature study to the Salon wall, it offers no invitation to enter the scene, no pathway to explore. It does, however, offer the promise of life, vitality, and renewal. No invitation to enter is really necessary, the flowers have come forward to meet us.

> How rich art is, if one can only remember what one has seen, one is never empty of thoughts or truly lonely, never alone. (Vincent to Theo, Laeken, November 15, 1878, 126)

75. Vincent van Gogh, *Sous-bois (Undergrowth)*. Oil on canvas, 73 × 92.7 cm (28¾ × 36½ in.). Amsterdam, Van Gogh Museum (F746).

One of Van Gogh's fascinating gifts was his visual memory. He was able to recall and describe images he had seen years before. In one instance, he was even able to sketch, in a letter,[161] and speculate (correctly) on the coloring of an Émile Bernard painting that Gauguin had described to Van Gogh a year earlier—but that Vincent had never seen. Perhaps Gauguin had sketched the composition for him, but it is nevertheless surprising that he was able to summon up its image after so much time had passed. In our consideration of *Irises* and how Van Gogh came to choose, compose, and depict his subject, we benefit from bearing in mind his wealth of visual knowledge of the history

of art. He had looked at art in such places as Amsterdam, The Hague, Brussels, Antwerp, London, Paris, and Montpellier—to name a few. His first priority upon joining his brother in Paris had been to visit the Louvre. He visited art galleries, exhibitions, and artists' studios. Paintings he had not seen in person—including many by his beloved Millet—he knew through the enormous market in reproductive photographs and prints, which he also collected. Although he referenced numerous artists and works in his letters, these allusions probably do not account for the total number of images that kept him from being lonely in the asylum. *Dandelions*, *Large Piece of Turf*, Dutch still lifes, and Japanese prints—these precedents for *Irises*'s unusual view of nature range far and wide and show the breadth of Van Gogh's artistic interests. They represent the catalog of images in his mind that gave license (if license was required) to come to a new perspective. Van Gogh's ability to see, to comprehend, and to fully absorb new and varied ideas into his work in the course of so short a career is at times dizzying. Yet the attraction of these particular precedents lay not only in their visual lessons but also, and perhaps more importantly, in their alignment with his artistic ideals—ideals that found expression in his way of working and living, in and with nature, and his hope for the spiritually rejuvenating role of art in life.

☒ ☒ ☒

Many of us, having seen *Irises*, forevermore associate the flower with Van Gogh, whether from the staying power of the image's bold composition and unique execution or from a more elusive strength—its expression of the exquisite nature of irises. Although Gauguin was speaking of Vincent's sunflowers, his response is equally apt for *Irises*: "That...it's...the flower." This almost inarticulate utterance holds within it the same duality (even plurality) of mean-

ings as the painting itself—that these are at once specific plants, growing in a specific place at a specific time, while also epitomizing the flower's essential qualities. Gorgeous, exuberant, tough, lush, stately, and yet almost baroque in their peculiar, ruffled blooms and twisting, flaming, writhing swordlike leaves, they are bodied forth, made three-dimensional, not in the traditional European post-Renaissance way, existing on a stage behind the screen of the canvas and confined to a world circumscribed by a frame, but instead shoving their way off the canvas, with total disregard for the illusion of recessive space and a palpable vitality that is almost animalistic.

When speaking of Van Gogh's work, the temptation to slip into poetic hyperbole is strong. His earliest critical defenders were Symbolist writers and poets who reveled in literary acrobatics in response to viewing his work. Félix Fénéon saw *Irises* at the Salon des Indépendants in 1889 and mentioned it positively, albeit briefly, in his review of the exhibition, describing how the plants "violently tear apart their violet patches against their sword-like leaves."[162] In 1890, Albert Aurier wrote the first significant analysis of Van Gogh's oeuvre;[163] his characterization of the man as a "terrible and panic-stricken genius" and of his work as "excess, excess of strength, excess of tension, violence of expression" contributed to the construction of the pervasive myth of Van Gogh as a tormented genius.[164] Bringing to bear the full force of his evocative language, he explained Vincent's work and his depiction of the natural world.

The disturbing, troubling display of an alien nature, a nature that is both really real and virtually supernatural, an excessive nature...beds of flowers that are less like flowers than the richest of jewels made of rubies, agates, onyx, emeralds, corundums, chrysoberyls, amethysts, and chalcedonies; the universal, mad and blinding coruscation of things...form becoming a nightmare, color becoming flames.[165]

Aurier highlighted the intensely expressive and personal nature of the painter's work and in so doing appropriated his work for the Symbolist agenda.

While Symbolists (and later the German Expressionists) may have admired Van Gogh for his subjectivity and what they saw as his emotional, reflexive relationship with nature, the artist himself and his ideas about art and the world were much more complex. In his recent studies of Van Gogh, Albert Boime emphasizes the artist's grounding of his work in the reality of his world but also notes his interest in the developments of science.[166] During the course of the nineteenth century, the study of the material world became something of a battleground, on which the value and meaning of what was observed could be interpreted in support of many causes. The expanding discourse of science, beginning perhaps as early as the systematic classification of life forms by Linnaeus and continuing through the theory of evolution as posited by Charles Darwin (and others),[167] was perceived by some as a threat to Christianity[168] and, by extension, to society itself. Without the order imposed by faith and religion, the fear was that society would lack both morality and stability. Therefore the stakes were high, and the search for truth became an urgent matter, as evidenced by the Marian revival among Catholics, the rise of movements such as Transcendentalism and socialism/Marxism, and the increased interest in philosophical and psychological concepts such as free will, consciousness, and intuition.

Something as simple as the elimination of recessive space in *Irises* takes on a new inflection when considered in this context. Jonathan Crary has observed that "in the texts of Marx, Bergson, Freud, and others the very apparatus that a century earlier was the site of truth [the camera obscura] becomes a model for procedures and forces that conceal, invert and mystify truth."[169] Ideas about vision and perception were being analyzed and challenged,[170] and disciplines that

might be thought disparate overlapped. Artists like Seurat and Van Gogh were studying, putting into practice, and conceiving new ideas about the perception of color. The historian Jules Michelet turned to natural science, publishing *L'Insecte*, *L'Amour*, and *L'Oiseaux*, in which he used his observations of the natural world and its social structures (human or not) to argue for a democratic pantheism.[171] Not far from Van Gogh in Provence, the self-taught entomologist Jean-Henri Fabre (1823–1915)[172] conducted his research by careful, close observation of insects and their interactions with each other and their environment. His popular publications, written in accessible, evocative language, drew conclusions about man from the observed behaviors of insects. He viewed instinct, which he conceived of as a "non-intelligent mechanism guiding animal actions that in human beings might be thought as the result of intelligence,"[173] as evidence of the divine and a counter to Darwin's theories. In a way, Fabre's method was strangely similar to Van Gogh's conception of the Japanese artist, as he turned to the small, seemingly insignificant things of nature to derive greater understanding of its guiding forces.

When we look at Van Gogh's painting *Starry Night* (figure 76), it is easy to believe that this image is about more than a night sky seen out the artist's window.[174] By conjuring the emotions Van Gogh felt when confronting the "stars in the firmament"—the insignificance of self within the universe, combined with a paradoxical revelation of that universe's interconnected relationships—this painting teaches us not only something about Vincent but also about the nature of existence, of suffering, of joy, of death, of ourselves. *Starry Night* takes its high viewpoint from the artist's bedroom window on the second floor and looks up at the galaxy, with the human world lying quietly below. *Irises* by contrast pulls us back down to earth (figure 1), to the ground, to focus on a single group of plants.[175] The painting may appear to be a simple nature study, but it promises something much more complex;

76. Vincent van Gogh, *The Starry Night*, Saint-Rémy, June 1889. Oil on canvas, 73.7 × 92.1 cm (29 × 36¼ in.). New York, Museum of Modern Art, Acquired through the Lillie P. Bliss Bequest, 472.1941. Photo: AR, N.Y.

that a thing concretely observed may be abstractly, spiritually, and personally understood.

> The greatest, most powerful imaginations have at the same time made things directly from nature that strike one dumb. (Vincent to Theo, Nuenen, late October 1885, 429)

> I assure you that it's quite something to resign oneself to living under surveillance, even if it is sympathetic, and to sacrifice one's liberty, to remain outside society with nothing but one's work as distraction. (Vincent to Theo, Saint-Rémy, May 4, 1890, 631)

Not many of us can fully comprehend what it meant to that fiercely independent man to relinquish his freedom by entering the asylum in Saint-Rémy. The lack of horizon, of room for movement, in the composition of *Irises* could be seen as an expression of his claustrophobia, or as a signifier of his avoidance of the situation and his forced optimism, willing himself to look not at the walls but at the beauty of flowers. But there were many flowers in the garden from which to choose, and Vincent chose irises.

Wisdom in Flowers

God made the flowers to beautify
The earth, and cheer man's careful mood;
And he is happiest who has power
To gather wisdom from a flower,
And wake his heart in every hour
To pleasant gratitude.

Attributed to William Wordsworth

Abbreviations: VG *is* Van Gogh; VtoT *indicates a citation from Vincent's letters to Theo;* VtoT/A, VtoT/I, *and* VtoT/S-R *the locations* Arles, Isleworth, *and* St.-Rémy.

1 Martin Bailey, "Drama at Arles: New Light on VG's Self-Mutilation," *Apollo* 523 (9/2005), pp. 30–41. Bailey argues persuasively that Vincent received the news just prior to his breakdown.

2 Dr. Félix Rey at the hospital in Arles had diagnosed VG as suffering from *epilepsie larvée* (larval or masked epilepsy); the doctors at St.-Rémy concurred. *See* Aaron Sheon, "VG's Understanding of Theories of Neurosis, Neurasthenia, and Degeneration in the 1880s," in J. D. Masheck, ed., *VG 100* (Westport, Conn., 1996), pp. 173–92, which discusses the research by a colleague of Rey's on the subject. The term *epilepsie larvée*, as defined in 1860 by Dr. Benedict Morel, meant that the patient suffered from epileptic attacks that were not physically convulsive but rather mental in nature. Because the patient was completely lucid in between episodes, he or she was not considered to be insane. *Accessions of acute mania occurred with great suddenness, and then as suddenly disappeared.... There were no prodromata other than an increased degree of activity and mental excitability, and they went on with their ordinary occupations up to the last moment. Then like a thunder-clap the seizure came, and in exactly the same form as previous attacks. Violence, extreme delirium, a tendency to the perpetration of acts of destruction or injury, irresistible impulsions, and then the subsidence of all the phenomena, and a return to the ordinary state of health. To this affection he gave the name of* epilepsie larvée: William A. Hammond, *A Treatise on Insanity in Its Medical Relations* (N.Y., 1883), p. 632. Potassium bromide, which VG received (*see* VtoT/A, 1/28/1889, 574), was perhaps the first somewhat successful drug in the treatment of epilepsy, though it had significant side effects, including skin rash and hallucinations, as Vincent mentions. *See* Walter J. Friedlander, *The History of Modern Epilepsy: The Beginning, 1865–1914* (Westport, Conn., 2001). Treatment at the Maison de Santé in St.-Rémy was primarily therapeutic baths. *See* Abbé L. Paulet, *St. Rémy de Provence: Son histoire nationale, communale, religieuse* (Avignon, 1907), p. 172.

3 *See* Saskia de Bodt, *De Haagse School in Drenthe*, exh. cat. (Assen, Netherlands, Drents Museum, 1997), and F. Leeman & J. Sillevis, *De Haagse School en de jonge VG*, exh. cat. (The Hague, Gemeentemuseum, 2005).

4 VtoT, Nuenen, early 9/1885, 423. The passage reads: *These last two weeks I have had a lot of trouble with the reverend gentlemen of the clergy, who gave me to understand,*

albeit with the best intentions and believing like so many others that they were obliged to
intervene—that I ought not to be too familiar with people below me in station. But while
they put the matter to me in these terms, they used quite a different tone with the "people
of lower station," namely, threatening them if they allowed themselves to be painted.
This time I went straight to the Burgomaster and told him all about it, pointing out that
it was no business of the priests, and that they ought to stick to their own sphere of more
abstract concerns. In any case, for the moment I am having no more opposition from
them and I hope it will stay like that.

5 *See* Ronald Pickvance, *VG in Arles*, exh. cat. (N.Y., Metropolitan Museum of Art,
 1984); Douglas Druick et al., *VG and Gauguin: The Studio of the South*, exh. cat. (Art
 Institute of Chicago, & Amsterdam, VG Museum, 2001); and Debora Silverman,
 VG and Gauguin: The Search for Sacred Art (N.Y., 2000).

6 Despite the efforts of his art dealer-brother, VG sold frustratingly little during
 his short career. In addition to the drawings commissioned in 1882 by his uncle,
 Vincent painted a series of decorative panels for a dining room in 1885. In 1890,
 the Belgian painter Anna Boch purchased *The Red Vineyards* (F495), now in the
 State Hermitage Museum in St. Petersburg, for 400 francs. He also exchanged
 works with other artists and at times paid bills with paintings and drawings. *See*
 Bogomila Welsh-Ovcharov, "'I Shall Grow in a Tempest': 100 Years Later," in *VG*
 100 (*see* note 2), pp. 5–18.

7 Jan Hulsker, *Vincent and Theo: A Dual Biography* (Ann Arbor, Mich., 1990), p. 353.

8 Marije Vellekoop in *Vincent VG: The Drawings*, exh. cat. (N.Y., Metropolitan
 Museum of Art, & Amsterdam, VG Museum, 2005), p. 298, cat. no. 101.

9 Vincent's interest in the marketability of flower painters Monticelli and Quost
 extended to his suggestion that Theo purchase their pictures for investment
 and resale.

10 Silverman 2000 (note 5), pp. 139–41, discusses VG's use of the yarn and his
 interest in the color theory of Michel Chevreul.

11 Chevreul's theories were accessible through his publications as well as through
 Delacroix's writings and Charles Blanc's influential *Grammaire des arts du dessin*
 (Paris, 1867; published in English as *Grammar of Painting and Engraving*, trans.
 K. Daggett (N.Y., 1874).

12 Michel Chevreul, *The Principles of Harmony and Contrast of Colours*, trans. C. Martel
 (London, 1860), p. 349.

13 Martin Jay, *Downcast Eyes: The Denigration of Vision in Twentieth-Century French*
 Thought (Berkeley, Calif., 1994); *see especially* chapters two and three, "Dialec-
 tic of Enlightenment" and "The Crisis of the Ancien Scopic Régime: From the
 Impressionists to Bergson." Jay recounts the shift away "from the geometri-

calized laws of optics and the mechanical transmission of light to the physical dimensions of human sight." For further discussion of philosophical and scientific developments in the intellectual history of vision, *see* Jonathan Crary, *Techniques of the Observer: On Vision and Modernity in the Nineteenth Century* (Cambridge, Mass., 1990).

14 Carolus Linnaeus, *Species Plantarum* (Holmiae [Stockholm], 1753), vol. 1, p. 38.

15 Letter to the author from Nigel Service, 4 7, 2007. I am most grateful to Mr. Service for his assistance.

16 This means that *Iris germanica* is the offspring of two other iris species and has a chromosome number of 2n=44; that is, it has two sets of chromosomes from two different iris species. The parents of *I. germanica* are a matter of debate. The wide range of plants results in some complexity in identification. *See* Nigel Service, "Subgenus Iris: The Bearded Irises," in *A Guide to Species Irises: Their Identification and Cultivation*, ed. Species Group of the British Iris Society (Cambridge, 1997), pp. 17–58. Mr. Service states (p. 27) that *I. germanica* "is a highly involved complex of more or less closely related irises."

17 I am greatly indebted to Clarence Mahan, former president of the American Iris Association and author of *Classic Irises and the Men and Women Who Created Them* (Malabar, Fla., 2006), for his identification of the irises and his willing tutorial in things iris. My discussion of *Iris albicans/florentina* owes much to his text.

18 Mahan 2006 (note 17), pp. 353–64. In this chapter, entitled "Iris Florentina," Mahan describes the tortuous taxonomical history of *Iris florentina* and *Iris albicans*.

19 Email to the author from Clarence Mahan, 3/10/2007.

20 Brian Mathew, *The Iris* (N.Y., 1981), p. 22.

21 Mathew 1981 (note 20), p. 22.

22 Mathew 1981 (note 20), p. 27.

23 This is the alternative of choice for viewers who prefer to identify the single white bloom with Vincent himself, as if he were a single, lonely "sport" in a sea of "normal" people. VG gave a sermon in London in October 1876, taken from Psalm 119: *I am a stranger on earth, hide not Thy commandments from me*, which is often cited as an early construction of his feelings of estrangement and isolation. *See* letter from VtoT in which he included the text (VtoT/I, 10/31/1876, 79). For one of many discussions of this topic, *see* Kathleen P. Erickson, *At Eternity's Gate: The Spiritual Vision of Vincent VG* (Grand Rapids, Mich., 1998).

24 Letter to the author from Nigel Service, 4/7, 2007.

25 R. T. Gunthner, *The Greek Herbal of Dioscorides, Illustrated by a Byzantine A.D. 512, Englished by John Goodyear A.D. 1655* (London, 1934), p. 5.

26 Margaret B. Freeman, "The Cloisters Gardens in the Month of May," *Metropolitan Museum of Art Bulletin* 37, no. 5 (5/1942), p. 128.

27 *See* Helen E. Ricketts, "The Use of Iris in Medicine and Perfumery," in *Les Iris Cultivés: Actes et Comptes-Rendus de la 1er Conférence International des Iris tenue à Paris en 1922* (Paris, 1923), pp. 175–83. Although the practice diminished in the second half of the nineteenth century, issue-peas were still sold, particularly in Italy and France, and discussed, even praised, in medical texts of the period for their "agreeable odour, acridity, and power of absorbing moisture": Robert Bentley et al., *Medicinal Plants* (London, 1880), p. 273.

28 H. Correvon & H. Massé, *Les Iris dans les jardins* (Geneva & Paris, 1907), pp. 13, 17. I have not been able to securely corroborate usage of *Herbe à la rage* and *Passe-rage* for *Iris germanica*. One plant still known today as *passerage* in wild and cultivated forms is *Lepidium*. John Lindley & Thomas Moore, *The Treasury of Botany* (London, 1866), p. 869, identify *petit passe-rage* as *Lepidium graminifolium*. Boyer's *French Dictionary* (Boston, 1849) equates *passe-rage* with dittander, a kind of peppergrass or cress (also genus *Lepidium*). However, H. Beauchet-Filleau, in his *Glossaire Poitevin: Essai le patois Poitevin ou petit glossaire* (Paris, 1869), identifies *passe-rage* as the patois term for iris, attributing the origins of the name to the plant's virtue of dissipating rabies. Another iris has also been associated with *passe-rage*; *Passarabia (passe-rage) Les italiens donnent ce nom a "Iris a odeur de gigot" [Italians give this name to "iris with a mutton-odor/stinking iris"] (Iris foetidissima, Linn.)*: Jacques Eustache de Sève, *Nouveau dictionnaire d'histoire naturelle* (Paris, 1818), vol. 24, p. 572.

29 Emile Zola, *The Earth*, trans. D. Parmee (London, 1980), p. 136.

30 Alphonse Daudet, *Jack*, trans. L. Ensor (London, 1890) p. 66.

31 Daudet 1890 (note 30), p. 360.

32 Gustave Flaubert, *Sentimental Education*, trans. R. Baldick (London, 1991), p. 32.

33 Guy de Maupassant, *Bel-Ami*, in *The Complete Works of Guy de Maupassant*, trans. F. Caesar de Sumichrast (London, 1917), p. 120.

34 Pliny first called the wild iris *gladiolus*, the diminutive of *gladius*, meaning "sword." *Gladiolus* now indicates a genus within the Iridicae family, to which irises also belong. Similarly, *glaïeul* in French can refer to both flowers of the *Gladiolus* genus and some types of marsh iris, e.g., *Iris pseudoacorus* (L.) or *Iris foetidissima. See* Émile Littré, *Dictionnaire de la langue française* (Paris, 1877).

35 The reasons proffered for the adoption of a simple flower for the royal symbol of France are numerous, ranging from its association with the Virgin Mary and the tradition that it was presented in a heavenly vision to Clovis, king of France, to its being a rebus for *fleur de Louis*. The coins of Louis VI and Louis VII are the earliest

on which the fleur-de-lis appears. *See* M. Rey, *Histoire du Drapeau* (Paris, 1837), and Michel Pastroueau, *Traité d'héraldique* (Paris, 1979).

36 Charles Lyte, "The Iris in History," in *A Guide to Species Iris* (note 16), p. 2.

37 From the collection *Flower-de-Luce* (Boston, 1867), pp. 8–9.

38 The flower's namesake, the goddess Iris, acted as messenger of the gods to both gods and men and had as her attribute the rainbow. The goddess's name has within it the double meaning of messenger (*eiris*) and rainbow (*iris*). Many writers attribute the naming of the flower to the rainbow of colors in which the plants produce blooms. Iris is most frequently "translated" as "message" in language of flowers publications.

39 *See* Colin B. Bailey & Philip Conisbee, *The Age of Watteau, Chardin, and Fragonard*, exh. cat. (Washington, D.C., National Gallery of Art and other institutions, 2003), p. 142, cat. no. 11. An engraving of Jean-François de Troy's *The Rendezvous at the Fountain* by Charles-Nicolas Cochin *père* similarly adds a moralizing verse addressed to Iris: *Flee, Iris, flee; beware of lingering here / While you seek coolness from these waters, / From a lover's words defend your heart, / For they light a fire difficult to put out* (Bailey & Conisbee 2003, p. 166, cat. no. 24).

40 Jules Michelet, *L'Amour* (Paris, 1859); trans. J. W. Palmer (N.Y., 1859), p. 253.

41 Jules Michelet, *La Femme* (Paris, 1860); trans. J. W. Palmer (N.Y., 1868), p. 186.

42 Marcus Mrass's excellent essay "Schwerter in Vasen und Gärten: Überlegungen zu Irisdarstellungen des ausgehenden Mittelalters," in *Mythos—Symbol—Gestalt*, exh. cat. (Dormagen, Germany, Kreismuseum Zons, 2002), pp. 53–74, points out that there is no single iconographical meaning for the iris and surveys the range of potential meanings in the Middle Ages.

43 Erwin Panofsky, *Early Netherlandish Painting* (Cambridge, Mass., 1958), vol. 1, p. 332. *See also* Lottlissa Behling, *Die Pflanze in der mittelalterlichen Tafelmalerei* (Weimar, 1957), and, particularly, Robert A. Koch, "Flower Symbolism in the Portinari Altar," *Art Bulletin* 46, no. 1 (3/1964), pp. 70–77.

44 Koch 1964 (note 43), p. 75, and Behling 1957 (note 43), p. 38.

45 *Prayers and Portraits: Unfolding the Netherlandish Diptych*, exh. cat. (Washington, D.C., National Gallery of Art, & Antwerp, Koninklijk Museum voor Schone Kunsten, 2006), p. 313.

46 There have been a number of recountings of the tale of Rosamund, the most famous of which is found in Lord Tennyson's *Becket* (1884). In *Callirrhoë: Fair Rosamund* (London & N.Y., 1884), Michael Field (joint pseudonym for Katherine Harris Bradley & Edith Emma Cooper) presents her as pure and sweet and even calls her Rosa Mundi: *A girl o' the country, delicately made / Of blushes and simplicity*

and pure / Free ardour, of her sweetness unafraid; / For Rosa Mundi, of this truth be sure, / Was nature's Rose not man's (p. 135).

47 The placement of Rosamund in a walled garden (referred to as a *hortus conclusus* in representations of the Virgin) at Godeston nunnery also plays into the representation of her as a Virgin-type.

48 Beverly Seaton, *The Language of Flowers: A History* (Charlottesville & London, 1995).

49 Druick et al., 2001 (note 5), pp. 11–12 and 77, discuss the revival of emblem books in the nineteenth century in England and the Netherlands and link the use of such visual material by Groningen preachers (like Van Gogh's father) with Vincent's own interests and artistic production.

50 When painting the sunflower series, Vincent described them to Theo only as "decorations." In later letters to the critic Albert Aurier (Saint-Rémy, 2/10 or 1/11/1890, 626a) and to his sister Wilhelmina, however, he associated sunflowers with "gratitude." *Thinking of this, but far away, I feel the desire to renew myself, and to try to apologize for the fact that my pictures are after all almost a cry of anguish, although in the rustic sunflowers they may symbolize gratitude.* (VG to Wilhelmina, St.-Rémy, ca. 2/20/1890, W20.)

51 Druick, et al. 2001 (note 5), p. 11.

52 Druick, et al. 2001 (note 5), p. 12.

53 *See* Tsukasa Kodera, "VG's Utopian Japonisme," in *Catalogue of the VG Museum's Collection of Japanese Prints* (Amsterdam, 1991), pp. 11–45; Griselda Pollock, "On Not Seeing Provence: VG and the Landscape of Consolation, 1888–89," in *Framing France: The Representation of Landscape in France, 1870–1914*, ed. R. Thomson (Manchester & N.Y., 1998), pp. 88–118; and Elisa Evett, "The Late Nineteenth-Century European Critical Response to Japanese Art: Primivitist Leanings," *Art History* 6, no. 1 (3/1983), pp. 83–106.

54 I am very grateful to Dr. John Collins at the National Gallery of Canada for taking the time to discuss their painting with me and for the excellent publication by Colin B. Bailey & Dr. Collins: *VG's Irises*, exh. cat. (Ottawa, National Gallery of Canada, 1999). *Iris* initially belonged to Vincent's sister Wilhelmina.

55 The dating of these studies, however, is somewhat problematic. An argument could be made associating *Garden with Butterflies*, for instance, with *Tree Trunks in the Grass* (Otterlo, The Netherlands, Kröller-Müller Museum, F676) and *Long Grass with Butterflies* (London, National Gallery, F672), both of which are larger, more open compositions dating to the spring of 1890.

56 The pasteboard on which *Iris* was painted was thinned and mounted on canvas sometime prior to entering the collections of National Gallery of Canada in 1954. *See VG's Irises* (note 54), p. 3.

57 Ella Hendriks & Louis van Tilborgh, *New Views on VG's Development in Antwerp and Paris: An Integrated Art Historical and Technical Study of His Paintings in the VG Museum*, joint PhD thesis, Universiteit van Amsterdam, 11/2006, p. 107.

58 Vincent was fervent about painting outdoors. He described tying down his canvas and planting his easel with stakes so that he could paint even in the mistral, the famous windstorm of Provence.

59 VG Museum conservator Ella Hendriks has noted, as have others, the difficulty of dating VG's painting strictly on the basis of brushwork. After developing or changing his style, he would at times cycle back to reexplore a previous mode.

60 VtoT/S-R, ca. 5/10–15/1889, 591.

61 There has been some debate as to the dating of *Iris*. My proposal that it belongs to the end of VG's time in Arles is hardly novel; R. Brettel & S. Schaefer et al., in *A Day in the Country*, exh. cat. (Los Angeles County Museum of Art, 1984), dated it to 4/1889 as well.

62 My thanks to John Collins for his firsthand examination of the painting, his color observations, and this apt phrase.

63 Ronald Pickvance, *VG in St.-Rémy and Auvers*, exh. cat. (N.Y., Metropolitan Museum of Art, 1986), pp. 185–86.

64 Voltaire, *Candide* (Paris, 1759); trans. L. Bair (N.Y., 2003), chap. 30, p. 110.

65 H. Correvon & H. Massé 1907 (note 28), p. 137. Correvon reports visiting Mirbeau's garden of irises in 1895. Given Mirbeau's praise of VG's work in 1891, the purchase of *Irises* in 1892 cannot be simply a symptom of the "Iridomanie" that Correvon ascribes to both Mirbeau and Monet (p. 138).

66 Originally recounted in Léon Daudet, "Claude Monet," *L'Action française*, 12 8, 1926, p. 1. Translation from John House, *Monet: Nature into Art* (New Haven, Conn., 1986), p. 225.

67 Richard Shiff, "Review of *Monet: Nature into Art* by John House," *Art Bulletin* 73, no. 1 (3/1991), p. 155. Shiff's article presents a nuanced study of the dialectic between Symbolist discourse and naturalist representation.

68 Translation from S. A. Stein, ed., *VG: A Retrospective* (N.Y., 1986), p. ?

69 VG read *Mes haines*, a collection of essays by Zola, in 1883. *See* Judy Sund, *True to Temperament: VG and French Naturalist Literature* (N.Y., 1992), pp. 75–80, 92–94. I have borrowed Sund's definition of temperament (p. 77). Sund (p. 93) discusses the complexities of VG's understanding and adoption of Zola's concept of temperament: *Under cover of Zola's defense of the individual artist's idiosyncratic response to nature, VG proffered the technical imperfections of his work as manifestations of temperament, and even implied that his autodidact's clumsiness was a testament to the unvarnished "truth" of his portrayal.*

70 Vincent to Wilhelmina, St.-Rémy, 9/14/1889, W14.

71 An exception to the mostly flat landscape is Montmajour, a rocky outcrop that was once an island in the Rhône marshes. While living in Arles, VG visited Montmajour and its famous ruined abbey, built over the course of the tenth through the thirteenth centuries, drawing and painting the ruins and views of the plains. The productivity of the farmland in and around Arles had received a boost in the nineteenth century through the expansion of irrigation and use of fertilizers. *See* Etienne Estrangin, *Mouvement économique. L'Agriculture*, vol. 7 of *Les Bouches du Rhône, Encyclopédie départmentale*, ed. P. Masson (Marseille, 1928).

72 Vincent's living quarters are thought to have been on the upper floor of the wing running north–south, with his window facing east toward the enclosed field (which he painted with a rising sun); his studio is believed to have also been located on the upper floor, but in the north wing with a south-facing view of the walled garden. *See*, among others, *The Paintings of Vincent VG in the Collection of the Kröller-Müller Museum* (Otterloo, The Netherlands, 2003), pp. 279–91.

73 Alphonse Daudet (1840–1897) set much of his work in Provence and reflected the ideals of the Félibrists. *Tartarin sur les Alpes* (Paris, 1885) was a sequel to his *Tartarin de Tarascon* (Paris, 1876), which VG enjoyed enormously. In *Tartarin sur les Alpes*, the Alpilles play the role of a gentle joke as they appear, like the hapless hero, to be more rugged and "dangerous" than they are in reality.

74 *Tartarin on the Alps*, trans. H. Frith (London, 1902), p. 32.

75 A number of authors have explored the extent of VG's literary knowledge and how his comprehension of Provence was filtered through the writings of Daudet, Guy de Maupassant, and Émile Zola. *See especially* Judy Sund, "A Bel-Ami of the Midi in the Land of Tartarin," chap. 5 in *True to Temperament* (note 69); also Vojtěch Jirat-Wasiutyński, "Vincent VG's Paintings of Olive Trees and Cypresses from St.-Rémy," *Art Bulletin* 75, no. 4 (12/1993), pp. 647–70.

 For a study of the Félibrist movement, *see* Alphonse V. Roche, *Provençal Regionalism* (Evanston, Ill., 1954). The regionalist movement was about more than just the preservation of language, culture, and landscape, it argued as well for the preservation (or return) of political rights and authorities to the regions. It raised the issue, pressing in the nineteenth century, of the shift of economic power as well as population to urban centers, particularly Paris. For artistic reflections of this dynamic, *see* Robert Herbert, "City vs. Country: The Rural Image in French Painting from Millet to Gauguin," *Artforum* 8, no. 6 (1/1970), and Griselda Pollock, "Vincent van Gogh and the Poor Slaves: Rural Labour as Modern Art," *Art History* 11 (1988), pp. 407–32.

76 VtoT/S-R, 10/5/1889, 609.

77 Vojtěch Jirat-Wasiutyński (note 75), p. 647.

78 The translation of quotations from letter 592 is taken from the forthcoming
 publication of letters by the VG Museum and the Huygens Institute, The Hague
 [October 2009].

79 Henri Antoine Revoil (1822–1900) was born in Aix-en-Provence. Having become
 architecte-en-chef des Monuments Historiques in 1849 and architecte diocésain in
 1852, Revoil was involved in many of the important restorations of historic
 monuments in the Midi during the nineteenth century.

80 The first coordinated major effort occurred in 1851 and was known as the
 Mission Héligraphique: five photographers were selected and sent out with a
 list of monuments (unfortunately not including St.-Paul-de-Mausole) to record.
 The resulting 258 images remained unpublished for some time. See Anne de
 Mondenard, La Mission Héliographique: Cinq photographes parcourent la France
 en 1851 (Paris, 2002), and Philippe Néagu, et al., La Mission Héliographique:
 Photographies de 1851 (Paris, 1980).

81 Renovations had been made during the eighteenth century to the exterior of the
 buildings that housed the patients.

82 These drawings/oil sketches (VG used a hybrid technique of thinned oil on
 paper) have been variously dated to May, June, and October, but Vellekoop 2005
 (note 8), pp. 322–26, convincingly argues for a September dating and suggests
 that he chose his subjects because he was not yet well enough to work outdoors.

83 Oil on canvas, 58 × 45 cm, Paris, Musée d'Orsay (F653).

84 The translation and dating of letter 605 is taken from the forthcoming
 publication of letters by the VG Museum and the Huygens Institute (note 78).

85 For the history of the monastery in all its phases, see Paulet 1907 (note 2),
 pp. 171–73; and Edgar Leroy, St.-Paul-de-Mausole à St.-Rémy-de-Provence: Notes
 historiques et touristiques (St.-Rémy-de-Provence, 1948).

86 In September 1889, Vincent painted portraits of the head attendant Charles-
 Elzéard Trabuc and his wife. They lived in a little farmhouse a stone's throw from the
 institution (VtoT/S-R, 10/5 or 10/6/1889, 604), near where the artist had painted
 some olive groves. The original paintings were given to the sitters and are now
 lost; copies (F629 [Kunstmuseum Solothurn] and F631 [St. Petersburg, State
 Hermitage]) sent to Theo survive.

87 Although often used interchangeably, sisters is "the correct noun for women
 who have taken simple vows within apostolic congregations" while the noun nun
 "should be used only to describe a woman who has taken solemn vows and lives
 in an enclosed order": Susan O'Brien, "French Nuns in Nineteenth-Century

England," *Past and Present* 154 (1/1997), p. 142. VG's phrase "good women" likely refers to the oft-used term *les Bonnes Soeurs*.

88 For a study of the rise of female religious orders in France in the nineteenth century, *see* Claude Langlois, *La Catholicism au féminin: Les congrégations françaises à supérieure générale au XIX siècle* (Paris, 1984); *see also* O'Brien 1997 (note 87), pp. 142–80. For the conflicted role of sisters within late-nineteenth-century France, *see* Judith F. Stone, "Anticlericals and Bonnes Soeurs: The Rhetoric of the 1901 Law of Associations," *French Historical Studies* 23, no. 1 (Winter 2000), pp. 103–28. For the debate within the medical establishment regarding religious workers in asylums, *see* William A. F. Browne, "Sisterhoods in Asylums," *Journal of Mental Science* 12, no. 57 (4/1866; publ. London, 1867), pp. 44–63; and L. F. E. Renaudin, "Administration des Asiles d'Aliénés," *Annuales Médico-Psycologique* 6 (Paris, 1845), pp. 14 and 225.

89 *I've noticed that others, too, hear sounds and strange voices during their attacks, as I did, and that things seemed to change before their very eyes. And that lessened the horror with which I remembered my first attack, something that, when it comes upon you unexpectedly, cannot but frighten you terribly* (VtoT/S-R, 5/22/1889, 592). *In answer to your letter of the 23rd inst., I have the satisfaction of telling you that Mr. Vincent has been perfectly calm since his entry into the house, and that every day he observes that his health improves. In the beginning he was subject to distressing nightmares which troubled him, but he observes that these distressing dreams have tended to disappear and decrease in intensity, resulting in a more restful and restorative sleep for him; he also has a better appetite* (Dr. Théophile Peyron to Theo, St.-Rémy, 5/26/1889); trans. R. Harrison; http://www.webexhibits.org/vangogh/letter/20/etc-Peyron-2-Theo.htm. Researchers, both in the nineteenth century and today, have observed a trend in religious experiences (feelings of exaltation, hallucinations, etc.) in patients with epilepsy, especially the form (*see* note 2) VG was thought to have. *See* Orrin Devinsky, "Religious Experiences and Epilepsy," *Epilepsy and Behavior* 4, no. 1 (1/2003), pp. 76–77.

90 *But what disturbs me is the constant sight of these good women who both believe in the Virgin of Lourdes and make up that sort of thing, and realizing that one is a prisoner of an administration that is only too willing to cultivate these unhealthy religious aberrations when it should be concerned with curing them* (VtoT/S-R, 9/7 or 9/8/1889, 605).

 Beginning in 1858, a teenage girl in a small town of Lourdes in southern France reported numerous apparitions of the Virgin Mary; Lourdes became one of the most important pilgrimage sites in Europe.

91 VtoT/S-R, 9/7 or 9/8/1889, 605.

92 Hazel Mills, "Negotiating the Divide: Women, Philanthropy and the 'Public Sphere' in Nineteenth-Century France," in *Religion, Society and Politics in France since 1789*, eds. F. Tallet & N. Atkin (London, 1991), pp. 29–54. *See also* Susan E. Dinan, "Overcoming Gender Limitations: The Daughters of Charity and Early Modern Catholicism," in *Early Modern Catholicism: Essays in Honour of John. W. O'Malley, S.J.* (Toronto & Buffalo, N.Y., 2001), pp. 97–113.

93 VG was hardly alone in his anticlerical feelings. He reports that Dr. Rey at the hospital in Arles would tease the sisters, telling them that romantic love was a bacterium (an infectious disease). In his *Fleurs du Mal* (1857), Charles Baudelaire included a poem entitled *Les Deux Bonnes Soeurs* (Sisters of Mercy), a play on the phrase "good sisters," whom he identifies as Debauchery and Death. *Debauchery and Death are pleasant twins, / And lavish with their charms, a buxom pair! / Under the rags that clothe their virgin skins, / Their wombs, though still in labour, never bear…* (excerpt from C. Baudelaire, *The Flowers of Evil*, ed. M. Mathews, trans. R. Campbell [N.Y., 1989], p. 157). In contemporary rhetoric, a *religieuse* stood as "an icon for irrationality, perversity, hysteria" and represented a potential threat to the state, not to mention any "pathological consequences of sexual repression": Stone 2000 (note 88), p. 110.

94 Historians have noted that VG was not raised in a strict Calvinist version of the Dutch Reformed Church but under the tenets of the more moderate Groningen branch. *See* Ann H. Murray, "The Religious Background of Vincent van Gogh and Its Relation to His Views on Nature and Art," *Journal of the American Academy of Religion* 46, no. 1 (1978), p. 66; Druick et al. 2001 (note 5), pp. 10–20; and Silverman 2000 (note 5), chapter 3.

95 Tsukasa Kodera, *Vincent van Gogh: Christianity versus Nature* (Amsterdam & Philadelphia, 1990), p. 42.

96 Vincent to Émile Bernard, Arles, ca. 8 21/1888, B15.

97 VtoT/A, 1/28/1889, 574.

98 VtoT/S-R, 5/22/1889, 592.

99 *Victor Hugo says God is an eclipsing lighthouse, and certainly now we are passing through that eclipse. I only wish that someone could prove to us something calming which comforted us, so that we stopped feeling guilty or unhappy and that we could go forward without losing ourselves in the solitude or nothingness, and without having to fear every step, or to nervously calculate the harm we may unintentionally be doing to others* (VtoT/A, 10/28/1888, 543).

 In the book, My Religion, Tolstoy implies that whatever happens in a violent revolution, there will also be an inner and hidden revolution in the people, out of which a new religion will be born, or rather, something completely new which will be nameless,

but which will have the same effect of consoling, of making life possible, as the Christian religion used to (VtoT/A, 10/24/1888, 542).

100 To be fair to Gauguin, he, too, seemed to require intercessory, real-life objects in order to approach his subject—whether it be a Breton sculpture for his *Yellow Christ* or the artist's own image for *Agony in the Garden*.

101 A number of important studies investigate VG's rejection of the religion in which he was raised and his view of nature as spiritualized subject matter. *See* Judy Sund, "The Sower and Sheaf: Biblical Metaphor in the Art of Vincent van Gogh," *Art Bulletin* 70 (12/1988), pp. 667–71; T. Buser, "VG as Religious Artist," *Gazette des Beaux-Arts* sér. 6., no. 114 (7/8/1989), pp. 41–50; Kodera 1990 (note 95); Jirat-Wasiutyński 1993 (note 75), pp. 647–70.

102 Lauren Soth reads VG's *Starry Night* as a "sublimated version of the Agony in the Garden": L. Soth, "VG's Agony," *Art Bulletin* 68, no. 2 (6/1986), pp. 301–13. For a materialist reading at the other end of the spectrum, *see* Albert Boime, "VG's *Starry Night*: A History of Matter and a Matter of History," *Arts Magazine* 59 (12/1984), pp. 86–103.

103 *See* Heather Bailey, *Orthodoxy, Modernity and Authenticity: The Reception of Ernest Renan's "Life of Jesus" in Russia* (Cambridge, 2008). Also Alan Pitt, "The Cultural Impact of Science in France: Ernest Renan and the *Vie de Jésus*," *Historical Journal* 43, no. 1 (2000), pp. 79–101.

104 *Pierre et Jean* (Paris, 1888); trans. J. Mead (Oxford, 2001), p. 7.

105 VtoT/A, 3/18/1888, 470.

106 VtoT/S-R, 5/3/1889, 590.

107 Sabine Schulze, "The Painter's Garden: Design-Inspiration-Delight," in the book of same title (Frankfurt am Main, 2007), p. 14.

108 VtoT/A, 10/3/1888, 544.

109 VtoT/A, 10/7/1888, 545.

110 Tsukasa Kodera, "Japan as Primitivistic Utopia: VG's Japonisme Portraits," *Simiolus* 14 (1984), pp. 189–208, connects VG's hope of the shared artists' studio with his utopian notion of a traditional rural society in which the artist is fully integrated, which he based on a fictional Japanese prototype.

111 VtoT/A, 10/7/1888, 545.

112 Van der Goes's life story, including a translation of a sixteenth-century chronicle of the cloister in which he lived, had been published in 1872: Alphonse-Jules Wauters, *Hugues van der Goes* (Brussels, 1872). *See also* H. C. Erik Midelfort, *A History of Madness in Sixteenth-Century Germany* (Palo Alto, Calif., 1999), pp. 26–32; and Nevet Dolev, "Gaspar Ofhuys' Chronicle and Hugo van der Goes," *Assaph* 4 (1999), pp. 125–37. *See also* Bradley Collins, Jr., *VG and Gauguin: Electric*

Arguments and Utopian Dreams (Boulder, Colo., 2001), pp. 110–12. Collins sees VG as identifying with numerous "cracked" artists, but most particularly with Van der Goes, and describes the notion of artist/monk as a "bulwark" against insanity.

113 Erwin Panofsky, *Early Netherlandish Painting* (Cambridge, Mass., 1953), p. 330. On pp. 337–38, Panofsky writes that "the outbreak of the storm can be witnessed" in his late paintings.

114 VG clearly seems to have accepted the contemporary idea that great artists live on the fringes of society and are often madmen. *When Delacroix paints humanity, life in general instead of an epoch, he belongs to the same family of universal geniuses. . . . Daumier is also a really great genius. . . . Possible that these great geniuses are no more than loonies, and that to have faith and boundless admiration for them you'd have to be a loony too. That may well be—I would prefer my madness to other people's wisdom* (VG to Émile Bernard, Arles, 7 30/1888, B13).

115 Ingo Walther et al., *Masterpieces of Western Art* (Cologne & London, 1996), p. 132.

116 Judy Sund 1992 (note 69), pp. 174–76, 227–28; and Kodera 1990 (note 95).

117 VtoT/S-R, 5/22/1889, 592.

118 *Abbé Mouret's Transgression*, trans. E. A. Viztelly (N.Y., 1915), p. 138.

119 One of the earliest of these monasteries was Gheel, to which Vincent's father had made early plans to commit his son. Initially a place of pilgrimage for the insane, by the nineteenth century the entire town was in the business and a modern medical institution was in place. St. Dymphna, interred in Gheel, is patron saint of the insane. Her feast day is 5/15, about the time VG was painting *Irises*.

120 Nancy Gerlach-Spriggs et al., *Restorative Gardens: The Healing Landscape* (New Haven, Conn., 2004); *see, particularly*, "The History," pp. 7–34.

121 The administration may not have had the financial means to do so; Vincent reported that there were as many as thirty empty rooms.

122 *See* note 78.

123 Paul Mariéton, *La Terre provençal: Journal de route* (Paris, 1890), part 2, pp. 129–31.

124 Admittedly, it is difficult to know how much of Mariéton's feeling of repulsion had to do with the actual architecture and how much with the notion of insanity and confinement.

125 VtoT/S-R, 5/22/1889, 592.

126 Jirat-Wasiutyński 1993 (note 75) discusses both the olive tree and the cypress as symbols of death and immortality. Not surprisingly, a giant, solitary cypress stands near the gate of a cemetery, casting its shadow upon the field in Zola's *La Faute de l'Abbe Mouret* (p. 22).

127 VtoT/A, 4/30/1889, 588; just days before his departure for St.-Rémy.

128 VtoT/S-R, ca. 7/9/1889, 600.

129　*See* Kodera 1991 (note 53), pp. 11–45; *also* Sund 1992 (note 69), pp. 171, 178–80, 188–89. There was a burgeoning industry in Japanese travel literature in this period. To give just one example, Émile Guimet returned from his travels to the Far East laden with objects for his personal museum as well as drawings made by Félix Regamey—whose prints of Japanese life VG knew as early as 1883 (letter R30)—with which he illustrated a report of their adventures, *Promenades japonaises. See* Ting Chang, "Disorienting Orient: Duret and Guimet, Anxious *Flâneurs* in Asia," in *The Invisible Flaneuse?: Gender, Public Space and Visual Culture in Nineteenth-Century Paris*, eds. A. d'Souza & T. McDonough (Manchester, England, 2006), pp. 65–78.

130　For VG, a "blade of grass" could be more than the literal plant. He wrote this about the wife of M. Trabuc, the head attendant at the asylum: *She is a faded woman, an unhappy, resigned creature of small account, so insignificant that I have a great longing to paint that dusty blade of grass:* VtoT/S-R, 9/7 or 9/8/1889, 604, translation from the upcoming publication of letters by the VG Museum and the Huygens Institute (*see* note 78). Mme Trabuc's insignificance is the very thing that attracts him to her as a subject.

131　This is a concept he gleaned in part from reading Siegfried Bing's journal, *Artistic Japan* (1888), vol. 1, p. 6: *In a word, he [the Japanese artist] is convinced that Nature contains primordial elements of all things, and, according to him, nothing exists in creation, be it only a blade of grass, that is not worthy of a place in the loftiest conceptions of Art.*

132　Kōrin's spectacular screen *Waves at Matsushima*, now in the Boston Museum of Fine Arts, was acquired in 1880 in Kyoto and brought to the United States by the influential scholar Ernest Fenollosa.

　　　　　Louis Gonse, editor of the *Gazette des Beaux-Arts* and an early advocate of Japanese art, discussed Kōrin's work enthusiastically in his *L'Art japonais* (Paris, 1883), vol. 1, pp. 231–35. Kōrin and the Rinpa/Rimpa school were important for the Art Nouveau movement. *See* Anna Jackson, "Tradition and Modernity: Japan and the Creation of Art Nouveau," in Paul Greenhalgh & Ghislaine Wood, eds., *Art Nouveau: An Architectural Indulgence* (London, 2000), pp. 38–45; *see also* Anna Jackson, "Orient and Occident," in P. Greenhalgh, ed., *Art Nouveau: 1890–1914* (London & N.Y., 2000), pp. 100–13.

133　*Sakai [Hoitsu] transferred to woodblocks ... two hundred of Ogata's paintings, privately publishing the first volume of one hundred pictures [Kōrin Hyaku-zu] for the 1815 Ogata centennial, the Buddhist ceremony.... The second volume followed ... in 1826:* Nishiyama Matsunosuke et al., *Edo Culture: Daily Life and Diversions in Urban Japan, 1600–1868* (Honolulu, 1997), p. 15. The *Iris* screen is included in volume 2 (1826).

I am very grateful to Anna Jackson, deputy keeper, Asian Department, Victoria and Albert Museum, for pointing me to this image and for her enthusiastic counsel; she also indicates that the Victoria and Albert copy had made it into a private collection in England by the later nineteenth century. A copy had been acquired by the Département des Manuscrits of the Bibliothèque nationale in Paris in 1843 in the acquisition of the collection of Philipp Franz von Siebold; see Phylis Floyd, "Documentary Evidence for the Availability of Japanese Imagery in Europe in Nineteenth-Century Public Collections," *Art Bulletin* 68, no. 1 (3/1986), p. 106. We do not know if VG saw the *Kōrin Hyaku-zu*, but it seems possible that he could have come across a copy in his avid exploration of Japanese art in the collections of friends and dealers.

Gonse wrote an article devoted to Kōrin for Bing's journal, *Artistic Japan* 4, no. 23 (4/1890), pp. 287–98, in which he stated, "There is no artist more originally or more profoundly Japanese," asserting that Kōrin was held in high esteem in Paris and listing a variety of nineteenth-century Japanese books that are collections of Kōrin's works. The article included a line illustration of an iris screen on p. 289. Unfortunately the date of publication is too late to be directly applicable to VG.

134 *Irises* is one of the few oil paintings that the Getty Museum protects with glass. The inviting tactility of the surface and the often worshipful nature of the excited visitor's experience made it all too tempting to reach out and touch this painting.

135 This word was used by Louis Gonse, in his 1883 publication on the graphic art of Hokusai and Hiroshige, to describe the Japanese artist, who *gives the viewer an affective or 'intuitive' experience by engaging him or her in an instantaneous image of a moment, free of the 'lourdeurs' [oppressiveness/airlessness] of Western conventions of time.* Quoted in Jan Hokenson, *Japan, France and East-West Aesthetics* (Madison, N.J., 2004), p. 331.

136 The authors of *The Studio of the South* (note 5), p. 203, have indicated that Gauguin's practice included beginning with a sketch in blue: VG *followed [for Memory of a Garden] Gauguin's preparatory methods exactly, establishing a dark-blue sketch and then a highly worked underpainting in pale blues and greens.*

137 The irises in Japanese prints grow in watery environments, so earth would not be present in any case. In more traditional figured landscape scenes and in the Kōrin screens, they can be seen springing up out of the water.

138 Literally, anthologies of flowers.

139 *See* Wilfrid Blunt, *The Art of Botanical Illustration: An Illustrated History* (N.Y., 1994); Paul Taylor, *Dutch Flower Painting 1600–1750* (London, 1996); and Arthur

Wheelock, *From Botany to Bouquets: Flowers in Northern Art*, exh. cat. (Washington, D.C., National Gallery of Art, 1999).

140 *See* the fascinating study by David Freedberg: *The Eye of the Lynx: Galileo, His Friends and the Beginnings of Modern Natural History* (Chicago, 2003).

141 Albrecht Dürer workshop, *Virgin and Child* (*Madonna with the Iris*), London, National Gallery of Art.

142 Hoffmann's *Hare* is his only known nature painting; his other surviving paintings are portraits and religious subjects.

143 Accustomed as we are to photography and to all types of painting from the Impressionists onward, not to mention Japanese art, it is easy to forget how avant-garde such cropping would have been at the time.

144 Moriz van Thausing, director of the Albertina collection in Vienna, which includes the *Large Piece of Turf*, commissioned numerous photographic and reproductive prints of Dürer's work and published an influential biography of the artist: *Dürer, Geschichte seines Lebens und seiner Kunst* (Leipzig, 1876). His earlier article, "La collection Albertina à Vienne, son histoire, sa composition," *Gazette des Beaux-Arts* (1870), was previously one of the most important studies on the subject and brought further international attention to the collection. *See* Walter Koschatzky, *Dürer Zeichnungen: Die Geschichte der Dürersammlung der Albertina* (Salzburg & Vienna, 1985), esp. pp. 87–90.

145 *See* James S. Patty, *Dürer in French Letters* (Paris, 1989). In addition to Victor Hugo, another French figure who admired Dürer is Charles Blanc, who published biographical and art historical information in *Histoire des peintres, École allemande* (Paris, 1875). Even Émile Bernard sent Vincent a sonnet entitled "Dessin d'Albrecht Dürer." In an early letter, Vincent brings together a disparate number of artistic characters using Dürer's *Melancholia* to define a universal mood—the harrowing of the human soul: *Méryon puts into his etchings something of the human soul, moved by I do not know what inner sorrow. I have seen Victor Hugo's drawings of Gothic buildings. Well, though they lacked Méryon's powerful and masterly technique, they had something of the same sentiment.... It is akin to what Albrecht Dürer expressed in his 'Melancholia,' and James Tissot and M. Maris (different though these two may be) in our own day. A discerning critic once rightly said of James Tissot, "He is a troubled soul."... There is something of the human soul in his work and that is why he is great, immense, infinite* (VtoT, Cuesmes, 4/24/1880, p. 136).

146 A perspective frame assisted an artist with the difficulties of translating a three-dimensional view onto a flat canvas or paper. VG first mentions Dürer's frame in 1882, but he was still using one in Arles in 1888.

147 Charles Ephrussi, *Albrecht Dürer et ses Dessins* (Paris, 1888), a collection of essays written for the *Gazette des Beaux-Arts* published between 1877 and 1880. Thanks to John Collins for the reminder of Ephrussi's Dürer efforts.

148 *That day I walked on past Gorest and took a side path leading to a little old ivy-grown church. I saw many linden trees there, still more interwoven, and more Gothic so to say than those we saw in the Park, and at the side of the hollowed road that leads to the churchyard there were twisted and gnarled stumps and tree roots, fantastical like those Albert Dürer etched in "Ritter, Tod and Teufel"* (VtoT, Laeken, 11/15/1878, 126).

149 VG painted his own thistles towering over a scene that he described as "thistles in an uncultivated field, thistles white with the fine dust of the road" and wrote that he was "attempting dusty thistles with a great swarm of butterflies" (VtoT/A, ca. 8/13/1888).

150 *The Studio of the South* (note 5), p. 273, discusses the appeal of the Japanese artist's attention to a blade of grass.

151 Alexandra R. Murphy, *Jean-François Millet*, exh. cat. (Boston, Museum of Fine Arts, 1984), p. 252.

152 Murphy 1994 (note 151), pp. 196–99, cat. nos. 135, 136; and Alexandra Murphy, *Jean-Francois Millet: Drawn into Light*, exh. cat. (Williamstown, Mass., Sterling and Francine Clark Art Institute, 1999), pp. 110–11, cat. no. 77.

153 Ninety-five drawings and pastels from the collection of Millet's great patron Émile Gavet were sold at the Hôtel Drouot, 6 11–12 1875 (*Dandelions* was listed as no. 94, *Primroses* as no. 47).

154 *See* Louis van Tilborgh, *Millet/VG*, exh. cat. (Paris, Musée d'Orsay, 1999), for a thorough analysis of VG's veneration of Millet.

155 Within a year of deciding on his artistic course, VG read Alfred Sensier's biography: *La Vie et l'oeuvre de J.-F. Millet* (Paris, 1881). For the impact of this biography on the conception of Millet as peasant-painter, *see* Christopher Parsons & Neil McWilliam, "'Le paysan de Paris': Alfred Sensier and the Myth of Rural France," *Oxford Art Journal* 6, no. 2 (1983), pp. 38–58.

156 *Une sorte de prophète capable d'interpreter la dimension religieuse de la nature:* Van Tilborgh 1999 (note 154), p. 40.

157 Millet also was an admirer of Dürer and Japanese art. The critic Théophile Silvestre also viewed the 1875 Gavet sale at the Hôtel Drouot and in his personal copy of the catalogue noted an affinity between *Dandelions* and Dürer's *Large Piece of Turf.*

158 The critic/historian Philippe Burty, known for his promotion of Japonisme, also wrote *Les Emaux cloisonnées anciens et modernes* (Paris, 1868).

159 Corrected translation from Jirat-Wasiutyński 1993 (note 75).

160 Paul Cézanne, working in Provence but with a very different landscape, also explored the *sous-bois* tradition. *See* his *Sous-Bois*, Los Angeles County Museum of Art, AC1992.161.11.

161 Vincent to Émile Bernard, St.-Rémy, ca. 11 20/1889.

162 Félix Fénéon, "Salon des Indépendants, Paris, 1889," *La Vogue* (9/1889); reprinted in *L'Art moderne de Bruxelles* (10/27/1889), and in *Oeuvre plus que completes*, ed. J. U. Halperin (Geneva, 1970), p. 168.

163 Albert Aurier, "Les Isolés," *Le Mercure de France*, 1 10/1890. All quotes taken from the English translation in Nathalie Heinich, *The Glory of VG*, (Princeton, N.J., 1996), appendix A, pp. 153–58. For complete and careful analyses of VG, Aurier, and other critical histories of VG, *see* Patricia Mathews, "Aurier and VG: Criticism and Response," *Art Bulletin* 68, no. 1 (3/1986), pp. 94–104; Carol Zemel, *Formation of a Legend: VG Criticism, 1890–1920* (Ann Arbor, Mich., 1980); and Heinich 1996.

164 Octave Mirbeau's praise of Vincent's talent and lamentation at his loss have similarly contributed to the romanticized myth.

165 Aurier, in Heinich (note 163), p. 154.

166 Albert Boime, "VG's *Starry Night*: A History of Matter and a Matter of History," *Arts Magazine* (12/1984) v. 59, pp. 86–103 and Albert Boime, "VG's *Starry Night*: After the Apocalypse a Heavenly Utopia," in *Revelation of Modernism* (Columbia, Mo., 2007), pp. 1–51.

167 Evolution challenged the idea that humans were of a different order of being from the animal world and was understood by some to negate the existence of the human soul. Without the soul, and thus without divine wrath and salvation, the concept and purpose of morality were seriously undermined.

168 Science was thought to refute the possibility of the supernatural, and therefore revelation, divine intervention, and miracles.

169 Jonathan Crary, *Techniques of the Observer: On Vision and Modernity in the Nineteenth Century* (Boston, 1992), p. 29.

170 *See, among others*, Jonathan Crary (note 169); Jay 1993 (note 13); and Jonathan Crary, *Suspensions of Perception: Attention, Spectacle and Modern Culture* (Boston, 2001).

171 Lionel Gossman, "The Alibi of Nature: Michelet and Natural History," in K. Karczewska, ed., *The World and Its Rival* (Kenilworth, N.J., and Amsterdam, 1999), pp. 201–48; and Linda Orr, *Jules Michelet: Nature, History and Language* (Ithaca, N.Y., 1976).

172 Jean-Henri Fabre was described by his biographer as the "poet of science" and by Victor Hugo as the "insect's Homer." Edmund Rostand, author of *Cyrano de*

Bergerac, described him as "this great scientist who thinks as a philosopher, sees as an artist and feels and expresses himself as a poet": George Victor Legros, *Fabre: Poet of Science* (N.Y., 1913), p. 347, n. 20.

173 Peter E. Langford, *Modern Philosophies of Human Nature*, vol. 15, Martinus Nijhoff Philosophy Library (Dordrecht, 1986), p. 10. Fabre and Darwin had great respect for each other and exchanged correspondence until the latter's death, *see* Legros 1913 (note 172).

174 While most writers have interpreted *Starry Night* solely symbolically, a few recent studies conductd with the assistance of astronomers have suggested that it represents very observed natural phenomena. *See* Boime 1984, 2007 (note 166).

175 Vincent himself, a year before painting *Irises* and *Starry Night*, made a similar comparison between paintings that look up at the sky and those that look down at the ground: *A starry sky for example, well—it's a thing that I should like to try to do, just as in the daytime I'll try to paint a green meadow studded with dandelions* (VG to Émile Bernard, Arles, ca. 4/12/1888, b03).

APPENDIX

DIGGING AT THE ROOTS
OF *IRISES*: PROVENANCE

On the whole there are a good many more people who can do clever sketches than there are who can paint readily and can get at nature through colour. That will always be rarer, and whether the pictures are a long time in being appreciated or not, they will find a collector some day. (Vincent to Theo, Arles, September 24, 1888, 542)

And those high prices one hears about, paid for work of painters who are dead and who were never paid so much while they were alive, it is a kind of tulip trade, under which the living painters suffer rather than gain any benefit. And it will also disappear like the tulip trade. (Vincent to his mother, Saint-Rémy, ca. October 20–22, 1889)

While *Irises* only achieved its world record price in the late 1980s—nearly a full century after its conception—it has long been admired by discerning collectors. The critic and avant-garde painter Félix Fénéon singled the painting out in his review of the Salon des Indépendants of 1889, enthusiastically describing irises that "violently tear apart their violet patches against their sword-like leaves."[1] Theo wrote Vincent encouragingly that after its appearance that summer at the Salon, people continued to talk about the painting.[2]

Irises was returned to Theo after its appearance in the Salon ("I've got your irises back; it is one of your good things" [Theo to Vincent, Paris to Saint-Rémy, October 21, 1889, T19]). It is unclear when *Irises* was transferred to Tanguy's establishment. Theo had rented a room in the late summer or early fall of 1889 in the house/shop of Vincent's color merchant, Julien (called Père) Tanguy, to store Vincent's paintings (letter 604), which were filling his own apartments. After Van Gogh's death, the pictures from his time in Auvers went directly to Tanguy. Following Theo's demise, Tanguy arranged for the sale of a number of paintings still in his shop; *Irises* appears to have been one of them. In addition to supplying artists with materials, Père Tanguy sold and displayed artwork in an informal gallery in his back rooms; Van Gogh's paintings were frequently on view there and in the window (letter 462). At times Tanguy accepted paintings from artists in exchange for supplies, but he also acted as a dealer, taking things on consignment for subsequent sale and having small "exhibitions." Vincent described his relationship with Tanguy as a friendship, which it seems to have been accurate despite a tussle over his accounts in 1888. He painted portraits of Tanguy (figure 77) and his wife while he was living in Paris; the portrait of Tanguy shows him seated against a wall of Japanese prints—which, incidentally, Tanguy neither collected nor sold.[3] Van Gogh admired Tanguy for his politics; he crops up in Vincent's letters as "that old republican." According to Émile Bernard, Tanguy was one of the few friends who came from Paris to Auvers for Vincent's funeral (letter to A. Aurier, August 2, 1890). In 1892, Octave Mirbeau purchased *Irises* and another painting, *Three Sunflowers* (private collection; F457) from Père Tanguy for the sum of 600 francs.[4]

The novelist, critic, and anarchist Octave Mirbeau (figure 78) was a great admirer of Van Gogh's work. In addition to the two works listed above he also owned *Cornfield with Cypresses* (London, National

77. Vincent van Gogh, *Portrait of Père Tanguy*, 1887. Oil on canvas, 92.1 × 74.9 cm (36¼ × 29½ in.). Paris, Musée Rodin. Photo: Erich Lessing / AR, N.Y.

78. Bary (active late nineteenth century), *Octave Mirbeau*. Albumen print, 74 × 42 mm (2⁷⁄₈ × 1⁵⁄₈ in.). Paris, Musée d'Orsay. Photo: Gérard Blot / RMN / AR, N.Y.

79. Henri Matisse (French, 1869–1954), *Auguste Pellerin II*, 1917. Oil on canvas. Paris, Centre Georges Pompidou, Musée national d'art moderne. Photo: Christian Bahier / Philipe Migeat / RMN / AR, N.Y.

Gallery) and wrote a memorial review of the Van Gogh retrospective at the Salon des Indépendants in 1891. He also wrote a pre-Existentialist novel entitled *Dans le ciel*, unpublished in his lifetime, about the tragic life of a painter named Lucien, which was based upon Vincent's life. Mirbeau's art criticism championed other avant-garde artists; he was an important supporter of Auguste Rodin, for example, and wrote an influential text that accompanied the Rodin/Monet show of 1889. In addition to the work of Van Gogh, his collection included paintings by

Berthe Morisot, Camille Pissarro (who painted Mirbeau's garden in 1892), Auguste Renoir, and Paul Cézanne. Following his death, the sale of his collection at the Durand-Ruel galleries on February 24, 1919, was highly anticipated. Mirbeau himself sold *Irises* to Auguste Pellerin in 1905 (figure 79).

Pellerin, whose fortune came from the manufacture of margarine, was one of the most important collectors of Impressionist and Post-Impressionist art in the early twentieth century. After a rather conservative start with porcelain and crystal objects and paintings by Camille Corot and Jean-Jacques Henner, he sold these to collect Impressionist paintings, particularly those of Manet—including the famous *Bar at the Folies-Bergère* (1882; London, Courtauld Institute). He later sold many of these to focus his collecting on Cézanne—though sculptures by Rodin and Aristide Maillol and an early Van Gogh *Peasant Woman* (1885; New York, Metropolitan Museum of Art) remained in his collection until his death in 1929. Pellerin's collection of Cézanne paintings is justly famous; its catalogue would "read like a curator's wish list for an ideal exhibition."[5] *Irises* is one of the works Pellerin sold during his lifetime (perhaps to make way for yet another Cézanne) to Bernheim-Jeune in Paris, a dealer from whom he had purchased much of his collection. The Galeries Bernheim-Jeune had already played an important role in Van Gogh's posthumous career by staging the 1901 retrospective that increased interest in and appreciation of his works. Unfortunately, records do not survive with Bernheim-Jeune regarding *Irises*'s precise purchase and resale dates, but it had been included in the 1901 retrospective while still in the collection of Mirbeau. By 1925,[6] *Irises* was in the hands of yet another discerning collector, Jacques Doucet (figure 80).

Doucet, who acquired *Irises* from Bernheim-Jeune, had earned fame and wealth as one of the most successful and influential couturiers of the late nineteenth and early twentieth centuries.[7] He told

80. Man Ray (American, 1890–1976), *Jacques Doucet*. Photographic print. Paris, Institut national d'histoire de l'art, bibliothèque (Collection Jacques Doucet).

Fénéon that at the tender age of twenty-one he began purchasing contemporary Impressionist art—Monet, Jean-François Raffaëlli, Degas. But it was when Degas introduced him to the art of the eighteenth century that his collecting began in earnest.[8] Doucet assembled a staggering collection of sculpture, furniture, decorative arts, and paintings, including such well-known masterpieces as Chardin's *House of Cards* and *Soap Bubbles*, and Sir Joshua Reynolds' *Omai* (London, private collection), all of which he housed in a suitably furnished and garnished eighteenth-century hotel.[9] The majority of this collection he sold in a record-breaking auction in 1912.[10] In addition, he encouraged scholars in their endeavors and collected substantial documentation relating to the history of art, which he donated in 1918 to the Univer-

81. *Interior of the Doucet Residence, Avenue du Bois*, 1925. Photographic print. Paris, Bibliothèque littéraire Jacques Doucet.

sité de Paris. Among the eighteenth-century paintings in his collection he also hung more contemporary items by Alfred Sisley, Degas, Honoré Daumier, and others. Following the sale of 1912, his acquisitions became increasingly modern; as he had done for the eighteenth-century works, he surrounded these paintings with furniture and decorative art appropriate to the era. In his home on the Avenue du Bois (figure 81), where he moved in 1913, *Irises* hung in the *cabinet du travail* (study) in the company of a Van Gogh *Sunflowers*; *Lièvre* and *Conversation sur la plage* by Manet; two landscapes by Monet; a study by Degas; three Cézannes (including a *Mont Sainte Victoire*)—these "represented the past in the face of Picasso, Matisse, Derain," whose works he also owned.[11] Eileen Gray, an Art Deco designer, created both furniture for

his new home and lacquer frames for the works by Van Gogh.[12] Paradoxically, as Doucet's designs for clothing were coming to be considered too conservative, he was associating with and buying the work of some of the most innovative contemporary artists. He purchased some of the icons of modernism—Picasso's *Les Desmoiselles d'Avignon*, Henri Rousseau's *The Snake Charmer*—and was a great supporter of Surrealism. The painter/poet André Breton served as an advisor and friend. Doucet's impressive collection of books and artistic book bindings now forms the Bibliothèque littéraire Jacques Doucet in Paris. *Irises* remained in his collection until his death in 1929, at which time it passed to his widow, Mme Doucet, née Jeanne Roger.

In 1929, just prior to his death, Jacques Doucet lent *Irises* to an exhibition at the Museum of Modern Art in New York.[13] The loan was arranged by César de Hauke (1900–1965),[14] an art dealer who worked both as a business partner and as an employee of Jacques Seligmann et fils, dealers with galleries in both Paris and New York.[15] De Hauke, then living in Paris and working somewhat independently[16] of Seligmann, inventoried the collection for the widowed Mme Doucet in June 1935. In 1934 and again in 1935, a Mr. Willems (for Seligmann et fils) had given Mme Doucet valuations for the collection, and negotiations began for the dealer to handle the sale of the works. Between Jacques Doucet's death and its first appearance in the Seligmann et fils stock books, *Irises* was exhibited a number of times. When displayed at the Exposition Universelle et Internationale in Brussels in 1937, it was still listed as from the collection of Mme Jacques Doucet.

The exact date and terms of *Irises's* acquisition by dealers is imprecisely documented. Germain Seligmann (figure 82) would later write that he had made "one of the firm's most important acquisitions in the field of modern art—two groups of paintings from the estate of the late Jacques Doucet;"[17] he goes on to mention *Irises*, Daumier's *Amateur d'Estampes*, and a fantastic group of Picassos, including

Desmoiselles d'Avignon. In this statement Seligmann indicates that the sales of the *Desmoiselles* and the *Irises* were concurrent. The sale of *Desmoiselles d'Avignon* was arranged in September 1937; its ultimate destination would be the Museum of Modern Art, though the financial arrangements were apparently not complete until January 1939, when the museum announced the acquisition.[18] *Irises* appeared in the Seligmann stock book of 1938/39 and was lent by "Jacques Seligmann & Co." (the New York office) to a Van Gogh exhibition held at the Worcester Art Museum and the Baltimore Art Museum in 1942. Stock books consistently record the painting through 1944/45; it then appeared in the "works of art sold, taken out of stock, etc" file for 1946.[19]

82. *Germain Seligmann*, 1920s. Photographic print, 25 × 20 cm (9⅞ × 7⅞ in.). Washington, D.C., Smithsonian Institution, Archives of American Art, Jacques Seligmann & Co. Records. Photo: James Garrett.

Although the painting was listed in the Seligmann stock books, ownership details are still by no means clear. De Hauke appears to have had a piece of the painting from the start; in a letter (March 14, 1945) from Seligmann in New York to De Hauke in Paris, the dealer writes: "As far as your interests here are concerned, as you already know, the VAN GOGH 'Irises' is still here." Notes on the back of a photo in the Seligmann files confuse the matter further, indicating that the firm had purchased the painting with a "½ interest" from the "New Society"[20] in 1939 and on May 6, 1947, sold it to their sometime business associate De Hauke. Another letter in the Seligmann archives (July 9, 1974) from Carol Cooney (of Seligmann) to Mrs. Parker (most likely Theresa D. Parker, long-time sales associate and director of the contemporary American art department of the firm's New York office, 1935–late 1970s) tries to sort out the *Irises* deal but only muddies the waters. Cooney claims that Seligman & Co. had taken the painting on consignment with a half-interest from the "New Society" and subsequently "sold its half interest in the painting to De Hauke in 1947 without an invoice." She also states that there was a photograph in the "Payson file" labeled "Sold by Knoedler 1947. Now Mrs. C.S. Payson." She also writes that "The book in which the sales are recorded lists Knoedler's as the purchaser in 1947, and all the documentation is filed under Knoedler. The photographs in the file are labeled John H. Whitney via Knoedler." Clearly there were a number of interested parties who had a piece of *Irises* during the Seligmann years.

According to her son, John Whitney Payson, Joan Whitney Payson (1903–1975; figure 83) hesitated in 1947 at the reported $80,000 price when she acquired *Irises* from the New York dealer Carmen H. Messmore of Knoedler, who told her to not be "stingy."[21] Presumably Knoedler had either purchased the painting from De Hauke or perhaps acted as Mrs. Payson's representative in purchasing it from him.

Born a member of the wealthy Whitney family of American finan-
ciers, Joan Payson began collecting art while quite young—reportedly
at age nineteen—and favored Impressionist and Post-Impressionist
work. Her philanthropy was significant; she donated artwork to the
Metropolitan Museum of Art in New York and was a supporter of the
Portland Museum of Art, as well as Colby College. An avid sports
enthusiast, she was a minor shareholder of the New York Giants and
objected to their move to San Francisco; following the team's defec-
tion to California, she worked to obtain a team for New York City,
eventually becoming cofounder and president of the New York Mets.
Irises hung with other artwork, including Picasso's *Au Lapin Agile*, at

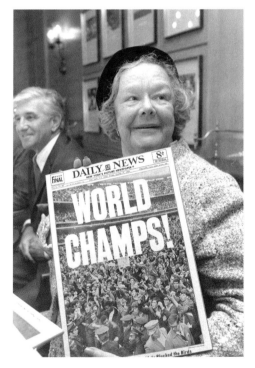

83. *Joan Whitney Payson*, 1969. Photograph from the *New York Daily News*.
 Photo: James Garrett.

Greentree, the Manhasset, New York, home she shared with her husband, Charles Shipman Payson.

Her son, John Whitney Payson, inherited the painting in 1975 and placed it on long-term loan with Westbrook College in Portland, Maine, for a decade. In 1987, he placed the painting for auction with Sotheby's, citing the increased cost in insurance, a recent and unprecedented spiral in art prices, and changes in Federal tax law.[22] He told the *New York Times* that

> The necessity of re-evaluation was increased by changes in the tax laws, which endangered the status of small museums in this country and contributed to a decrease in my financial ability to continue the long Whitney and Payson family traditions of supporting worthy public causes and institutions.[23]

Van Gogh was mistaken when he predicted that the high prices for the work of dead painters were temporary, as ephemeral as the boom in prices paid in the seventeenth century for tulips. Nearly one hundred years after his death, on November 11, 1987, *Irises* made history by becoming the world's "most expensive painting," selling at auction in fierce bidding over a dizzying two minutes or less (figure 84). The *New York Times* reported that there was "a gasp throughout the room as John L. Marion, chairman of Sotheby's North America and the auctioneer, began the bidding at $15 million....When Mr. Marion brought down the hammer at $49 million, there was resounding applause."[24] A commission to the auction house of 10 percent, known as the "buyer's premium," brought the final purchase price to $53.9 million. Although other paintings have since sold for more, notably Van Gogh's *Portrait of Dr. Gachet* in May 1990 for a staggering $82.5 million, the sale of *Irises* remains for many the symbol of the "'80s art boom."[25] Following closely on the heels of Black Monday, October 19, 1987, when

84. Auction of *Irises*, Sotheby's salesroom. Photo from the *New York Times*, November 12, 1987. Photo: Ruby Washington/ Redux Pictures.

the stock market plunged 508 points, *Irises*'s heady success was taken as a cause for celebration, a sign of the art market's stability in the face of other weakening economic indicators.

But the story, of course, did not end there. The Australian tycoon Alan Bond (figure 85) had been the purchaser, with the controversial assistance of a $27 million loan from Sotheby's finance department. Bond's subsequent financial downfall and default led Sotheby's to repossess the picture just two years later in 1989. Placing the painting back on the auction block was not considered an option, as the general consensus was that it would not again reach its record price and would thereby disrupt market prices across the board. In 1990, the Getty Museum acquired Van Gogh's *Irises* in a private purchase from Sotheby's for an undisclosed sum and brought it to California. The literature outlining the purchase, the deal between Bond

85. *Alan Bond*, 1985. Photo: Rennie Ellis Photographic Archive.

and Sotheby's, and its place in the 1980s art market almost seems to outnumber critical discussions of the work itself.[26]

In 1990, the Getty Museum was still a young, upstart museum. It had been established only in 1954, opening in the Malibu, California, ranch house of J. Paul Getty, who had built a fortune in oil. In 1974, a new museum, modeled after the Roman Villa Papiri, which had been destroyed at Herculaneum in the eruption of Vesuvius in AD 79, was completed on the same property. The small collection, primarily antiquities and French decorative arts, tucked sleepily up a canyon outside of Los Angeles, was for some time either unknown or viewed as quirky and quaint, with its rather theatrical structure considered appropriate to the Hollywood/Los Angeles area. When Getty died in 1976, he left a third of his fortune to the museum for the "diffusion of artistic and general knowledge." On February 8, 1982, after a protracted legal dispute with the surviving family, the Getty Museum and Trust received its bequest, which had grown from $700 million

to $1.2 billion. By 2000, the endowment was worth around $5 billion. The Getty's newfound wealth generated fears that the museum, in a buying frenzy, would artificially inflate market prices.[27] The acquisition of the Van Gogh seemed to many to cap off a nightmarish nouveau-riche moment in the art world, as the "most expensive painting in the world" traveled from hyped sale to scandalous debacle to the "richest" museum in the world. Happily, memories fade and attention can return to the painting itself rather than the swirling issues of the art market. The Getty Trust built a new modernist building called the Getty Center in the Brentwood section of Los Angeles to house the J. Paul Getty Museum's art collection; *Irises* remains the object most frequently asked for by visitors.

NOTES TO THE APPENDIX

1 Félix Fénéon, "Salon des Indépendants, Paris, 1889," *La Vogue*, September 1889.
 Reprinted in *L'Art moderne de Bruxelles* (October 27, 1889) and in *Oeuvre plus que
 completes*, ed. Joan U. Halperin (Geneva, 1970) p. 168.

2 Theo to Vincent, Paris, November 16, 1889, T20: "However bad the Indépendants
 was, the 'Irises' was seen by a lot of people, who now talk to me about them every
 once in a while."

3 *See* Tsukasa Kodera, "Van Gogh's Utopian Japonisme," in *Catalogue of the Van
 Gogh Museum's Collection of Japanese Prints* (Amsterdam, 1991), pp. 23–24, for an
 interesting discussion of Van Gogh's association of Tanguy with Japanese art and
 artists.

4 Octave Mirbeau, *Notes sur l'art* (Caen, France, 1990), p. 15. See also Bogomila
 Welsh-Ovcharov, "The Ownership of Vincent van Gogh's 'Sunflowers,'" *Burling-
 ton Magazine* 140, no. 1140 (March 1998), pp. 188–89.

5 Karen Wilkin, "Monsieur Pellerin's Collection: A Footnote to Cézanne," *New
 Criterion* (April 1996), p. 18.

6 In that year it was lent by Jacques Doucet to the exhibition "Cinquante ans de
 peinture francaise, 1875–1925" at the Musée des Arts Décoratifs in Paris, where
 it was listed as no. 79.

7 Francois Chapon, *Mystère et splendeurs de Jacques Doucet, 1853–1929* (Paris, 1984).
 Chapon points out that though Doucet made great contributions to the study of
 the history of art by collecting documentation on art and artists, he destroyed
 many of his own records.

8 Félix Fénéon, "Les grands collectionneurs, IX, M. Jacques Doucet," *Le Bulletin de
 la vie artistique* 11, no. 2 (June 11, 1921), pp. 313–18.

9 His first residence was at 19, la Rue Spontini, until 1907, then at 27, rue de la
 Ville-l'Eveque. See Chapon (note 7), p. 81.

10 "$3,054,000 Reached in the Doucet Sale; Furniture and Bronzes, Sold on Last
 Day, Total Almost Half a Million," *New York Times*, June 8, 1912. Another sale in
 1906 preceded Doucet's move to the rue de la Ville-l'Eveque.

11 André Joubin, "Jacques Doucet 1853–1929," *Gazette des Beaux-Arts* (January 1930),
 p. 74. Unfortunately the placement of *Irises* in Doucet's home is known only
 through Joubin's description; no photographs of the room in which it was hung
 survive.

12 Philippe Garnier, "The Lacquer Work of Eileen Gray and Jean Dunand," *Connois-
 seur* 183, no. 735 (May 1973); and Chapon (note 7), pp. 203–4. Sadly, so far as is
 known, none of these frames survive. In addition to his new home on l'Avenue du
 Bois, Doucet maintained a magnificent Art Deco studio on the rue Saint-James

in Neuilly-sur-Seine. De Hauke's inventory of Doucet's collection includes a third Van Gogh, *Le Chemin de fer*.

13 "Cézanne, Gauguin, Seurat, Van Gogh," exhibition held at the Museum of Modern Art in New York, November 1929 (as no. 95). The painting was insured for 600,000 francs.

14 *Who could forget Cesar de Hauke, the author of the catalogue raisonné of Seurat's paintings and drawings, with his tweed suits of contrasted green and purple checks? Such was his passion for great drawings that he would hang an empty frame on the wall to remind himself to find another great drawing*: John Russell, "The Gift of a Great Dealer—And Collector," *New York Times*, August 21, 1988.

15 Born in Europe to French/Polish parents, César de Hauke arrived in the United States in 1926. *While in New York City, he was introduced to Germain Seligman by Germain's cousin, René Seligmann, and by 1927 de Hauke had joined Jacques Seligmann & Co., Inc., as a sales representative…Seligman and de Hauke decided to explore the feasibility of sales in [modern French painting] by forming a subsidiary to Jacques Seligmann & Co., Inc., that would specialize in contemporary European artists. In 1926 Seligman personally financed the fledgling company, first called International Contemporary Art Company, Inc., and he appointed de Hauke its director, but even before the legal documents setting up the company were completed the name was changed to de Hauke & Co., Inc. Although the bulk of the new company's art purchases took place in Paris and London, the majority of its sales occurred in the United States … Seligman and de Hauke worked out an agreement allowing de Hauke to purchase works of art that could then be sold as stock inventory of Jacques Seligmann & Co., Inc., or privately under de Hauke's own name. Ownership of paintings was often shared among various art dealers, involving complicated commission transactions upon completion of sale. Seligman provided display space for de Hauke & Co., Inc., at the new, larger gallery of Jacques Seligmann & Co., Inc., now located at 3 East Fifty-first Street. The two businesses were deeply intertwined, as evidenced by the facts that Seligman's financial records include a great deal of de Hauke material and many of de Hauke's records are written on the stationery of Jacques Seligmann Co., Inc. De Hauke & Co., Inc., was dissolved and re-formed under the new name, Modern Paintings, Inc. César M. de Hauke was appointed its director, but tensions had crept into the relationship between the former partners, and by 1931, de Hauke had resigned and returned to Paris*: quoted from the finding aid for Jacques Seligmann & Co. Records, 1904–1978, Archives of American Art, Smithsonian Institution, Washington, D.C.

16 Although their formal business relationship had been dissolved, De Hauke and Seligmann appear to have continued to participate in shared transactions.

17 Germain Seligmann, *Merchants of Art: 1880–1960* (New York, 1961), pp. 179–80.

18 Provenance Research Project, Archives, Museum of Modern Art, New York.

19 See the Seligmann archives at the Archives of American Art, Smithsonian Institution, for records on the inventory, valuations, stock books, etc. The finding aid for the archives may be found at: http://www.aaa.si.edu/collections/findingaids/jacqselc.htm. The collection remains for the most part unmicrofilmed.

20 "New Society" remains as yet unidentified.

21 Rita Reif, "Van Gogh's Irises Sells for $53.9 Million," *New York Times*, November 12, 1987.

22 Rita Reif, "Van Gogh's Irises to Be Sold," *New York Times*, September 3, 1987.

23 Reif 1987 (note 22).

24 Reif 1987 (note 21).

25 Carol Vogel, "The Art Market," *New York Times*, November 22, 1991.

26 Among innumerable others, see Carol Zemel, "What Becomes a Legend Most," *Art in America*, July 1988; Nathalie Heinich, *The Glory of Van Gogh: An Anthropology of Admiration* (Princeton, N.J., 1996); Carol Zemel, *Van Gogh's Progress: Utopia, Modernity and Late-Nineteenth-Century Art* (Berkeley, Calif., 1997), p. 171; Robert Lacey, *Sotheby's: Bidding for Class* (Boston, 1998), pp. 254–61; John Russell, "Art: When a Painting Brings Millions, It's Art for Hype's Sake," *New York Times*, November 22, 1987; Robert Hughes, "The Anatomy of a Deal," *Time Magazine*, November 27, 1989; Ben Heller, "The Irises Affair," *Art in America* 78, no.7 (July 1990), pp. 45–53; M. De la Barre, S. Docclo, and V. Ginsburgh, "Returns of Impressionist, Modern and Contemporary European Paintings, 1962–1991," *Annales d'Economie et de Statistique* 35 (1994), pp. 143–81.

27 Douglas McGill, "Getty, The Art World's Big Spender," *New York Times*, March 4, 1987. McGill determines that fears of the inflating impact of Getty spending have proven unfounded.

INDEX

ACKNOWLEDGMENTS

I would like to extend my sincere gratitude to all those who have offered their remarks and encouragement during the writing of this book. I must thank Scott Schaefer, senior curator of Paintings at the J. Paul Getty Museum, for the opportunity he afforded me and for his patience. I am most appreciative of Scott and Mary Morton's comments; they helped me to greatly improve the focus and tone of the text. In particular, I wish also to thank the members of the Paintings Department of the Getty Museum, both past and present, with whom I have had the pleasure of working and associating: Denise Allen, David Jaffé, Dawson Carr, and Anne Woollett listened, encouraged, and advised when the project was just an idea for a modest article. Scott Allan and Charlotte Eyerman kindly answered random questions and supplied information. George R. Goldner, chairman of the Metropolitan Museum's Drawings and Prints Department, gave generously of his time to discuss the purchase and Getty history. I must also thank members of Paintings Conservation at the Getty Museum: Conservator Mark Leonard, for the periodic questions he has answered about Van Gogh and *Irises* and for the education in looking I received while at the Museum and Tiarna Doherty, Associate Conservator, who graciously responded to my inquiries about her own investigations into Van Gogh's work in 1889. At the Getty Research Institute library, Jay Gam always provided friendly support.

There are numerous others outside the Getty who have made substantial contributions to this undertaking. My thanks to Ella Hendriks, head of Conservation at the Van Gogh Museum, for allowing me a look at her thesis and for answering numerous questions. I am grateful to John Collins, assistant curator at the National Gallery of Canada, for his generous suggestions as well as first-hand observations. At the Victoria and Albert Museum, Anna Jackson, deputy keeper in the Asian Department, gave invaluable advice on *Japonisme*, Kōrin, and the West and Rupert Faulkner, Dominica Peters, and Roxanne Peters assisted in identifying and obtaining relevant photographs. I thank the staff of the Library and Research and Documentation at the Van Gogh Museum for their friendly help and guidance, Fieke Pabst in particular. Staff of the Cornell University libraries furnished advice and a steady stream of books. Finally, I thank Professor Peter Brunt at the Victoria University in Wellington, New Zealand, for his assistance with access to libraries there.

In Getty Publications, I am grateful to Mollie Holtman, my tireless, faithful editor/cheerleader. Cynthia Newman Bohn provided meticulous copy editing. Thanks also to Ruth Lane, photo researcher, who was determined in the pursuit of images, and to Anita Keys, production coordinator, who smoothly arranged all. The beautiful design of the book is attributable to the skill of Catherine Lorenz.

This book would never have been completed without the support and encouragement of my family and my husband, Todd Harvey.